IMAGES
of America

SANDY BAY NATIONAL HARBOR OF REFUGE AND THE NAVY

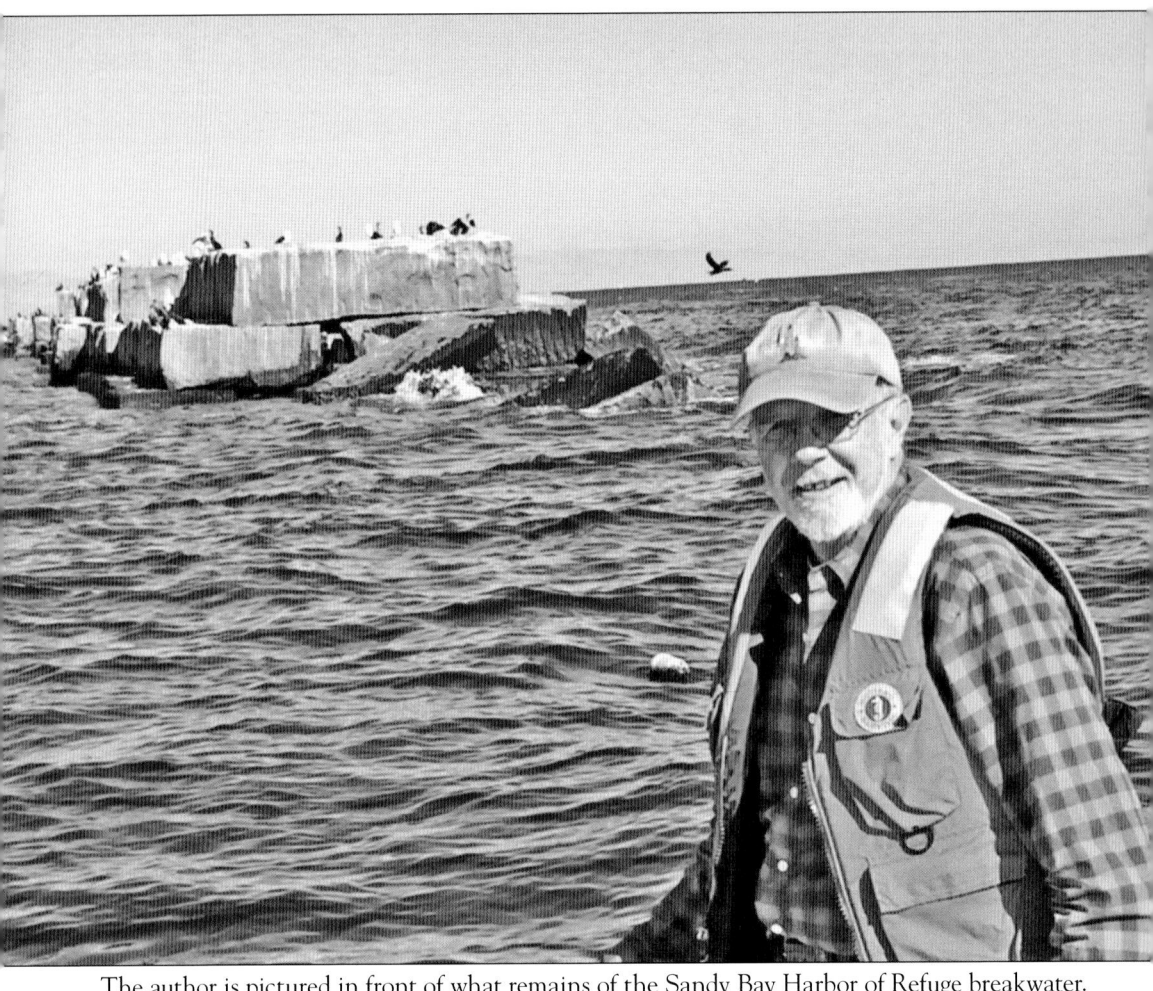

The author is pictured in front of what remains of the Sandy Bay Harbor of Refuge breakwater. In 1916, only 922 feet of the planned 9,000-foot breakwater had been completed when the project was abandoned. Over the past 100 years, numerous nor'easters and hurricanes have reduced it to less than 300 feet. It is ironic that what remains has become a hazard to boaters as hundreds of feet of the substructure is just below the surface creating a dangerous man-made reef. (Courtesy of Bill Whiting.)

ON THE COVER: Sightseers are viewing the arrival of the North Atlantic Fleet from a vantage point at Granite Pier. In 1906, to demonstrate the need for a harbor of refuge, 35 ships once anchored in Sandy Bay. The ships shown here are the USS *Michigan*, the USS *Nebraska*, and the USS *Delaware* in port for maneuvers in 1911; not pictured were five other battlewagons present. (Courtesy of Sandy Bay Historical Society.)

IMAGES
of America

SANDY BAY NATIONAL HARBOR OF REFUGE AND THE NAVY

Paul St. Germain

Copyright © 2018 by Paul St. Germain
ISBN 978-1-4671-2870-4

Published by Arcadia Publishing
Charleston, South Carolina

Printed in the United States of America

Library of Congress Control Number: 2017956956

For all general information, please contact Arcadia Publishing:
Telephone 843-853-2070
Fax 843-853-0044
E-mail sales@arcadiapublishing.com
For customer service and orders:
Toll-Free 1-888-313-2665

Visit us on the Internet at www.arcadiapublishing.com

To my dad, who infused me with a love of everything nautical and maritime

Contents

Acknowledgments		6
Introduction		7
1.	A National Harbor of Refuge of the First Class: 1880	9
2.	Building a Breakwater: 1884	19
3.	Ships of the Line, the Navy's First Visit: 1899	29
4.	The Commanders: 1899–1906	45
5.	The "Blue and White" War: 1902	59
6.	Fun and Games, a Sociable Navy: 1906	79
7.	The Great White Fleet in Rockport: 1902–1915	99
8.	End of the Breakwater and the Battleship: 1915	117
Bibliography		127

Acknowledgments

I must thank my dad, who first introduced me to the maritime world at a very early age. He was chief naval architect at the Boston Navy Yard in Charlestown, Massachusetts. He had an accomplished career during World War II, when he led his team to repair not only American ships but French naval vessels as well. My dad spoke fluent French, and I remember him and my mom hosting many French naval officers and enlisted men for dinners at our home. He also worked on the first steam-driven aircraft launching systems for aircraft carriers and installation design work for Terrier missile systems on the first guided-missile cruisers. His office looked out on the USS *Constitution*, which he had worked on for one of her refits in the 1950s. Dad would often take me in to see newly arrived naval vessels that he was working on. I remember him showing me nuclear warheads in the magazine of a guided-missile cruiser. He had access to many building plans of old warships from which he built scale models. He once built a model of *PT-109*, which was presented to John F. Kennedy before he became president; it sat on a table behind his desk in the Oval Office. His professional and personal expertise in maritime and naval history seems to have rubbed off on me. I think he would enjoy this book written by his son.

A big thank-you goes to Gwen Stephenson, director of the Sandy Bay Historical Society, for her help and permission to rummage through the society's files of photographs and books for documentation on both naval visits as well as the building of the breakwater.

I'd like to make special mention of the vast online photograph collections at the Naval History and Heritage Command website related to the US Navy. NHHC is responsible for the preservation, analysis, and dissemination of US naval history and heritage and was a major source for the book.

The National Archives and the Library of Congress were also important sources providing many unique photographs.

The images in this volume appear courtesy of the Library of Congress (LOC), Naval History and Heritage Command (NHHC), Sandy Bay Historical Society (SBHS), and the Cape Ann Museum (CAM).

Introduction

Historians have often term the period from 1890 to 1920 as the Progressive Era. It was a time of widespread social activism and political reform across the country. The Progressive movement objective was the elimination of problems caused by industrialization, urbanization, immigration, and corruption in government.

It was led by a group of forward-thinking presidents—Theodore Roosevelt, William Howard Taft, and Woodrow Wilson—who were open to new ideas.

Many social and political issues came to the forefront, like Prohibition, women's suffrage, the breaking up of monopolies, and the imposition of the first income tax.

It was a time of war. The Boxer Rebellion took hold in China in 1900, the Russian Revolution was initiated in 1905, and the Spanish-American War began with the sinking of the USS *Maine* in Havana Harbor on February 15, 1898. The slogan "Remember the *Maine*, the hell with Spain" was heard everywhere. Adm. George Dewey captured the Philippines and Manila Harbor with a squadron of six battleships and cruisers, including his flagship, the USS *Olympia*. Japan was flexing its muscles in the Pacific, and Germany threatened the United States with its submarine fleet on our East Coast.

America was building up its naval fleet in the Atlantic to protect its interests and defenses. Roosevelt's Great White Fleet went on a world tour with 16 battleships from 1907 to 1909 to show off America's naval might.

It was a time of major growth and technological breakthroughs, the opening of the Panama Canal in 1914, the admission of five new states to the union, and the creation of the National Park System and the National Park Service, each heralding a new age into the 20th century. The age of invention produced Marconi's radio 1901, the Wright brothers' first flight in 1903, Einstein's theory of relativity in 1905, and Ford's Model T in 1908.

The need for advanced maritime facilities to showcase its newly enhanced Navy and to protect commercial shipping interests was a priority to the White House Progressives of the time.

A report in an 1890 edition of the *Gloucester Telegraph and News* gave a list of vessels wrecked between the Ports of Boston and Portsmouth from 1828 to 1883, documenting over 300 wrecks and 374 partial wrecks. The government long ago recognized the dangers inherent with the seas around Cape Ann. It placed within a radius of six miles as many as six lighthouses and, in later years, established five Life-Saving stations. The number of maritime disasters spurred local shipping trades and the federal government to act. Around 1880, interest developed in building a gigantic breakwater in Rockport Harbor, off the North Shore of Massachusetts. Its purpose was to provide safe harbor to all vessels passing by Cape Ann. It was to be called the Sandy Bay National Harbor of Refuge and would consist of a V-shaped granite wall that would enclose 1,664 acres, affording anchorage ground for 5,000 ships. It was designed to be a harbor of refuge for maritime shipping bound to or from the coasts of Maine, New Hampshire, or the Maritime provinces. The need was great as statistics of the time indicated that upward of 70,000 vessels passed Sandy Bay annually. The only easily entered, deepwater harbors were Boston, located 23 miles to the south, and Portsmouth, 24 miles to the north.

The engineering and design work was unique and one of the most notable examples of marine engineering on record. Granite came from the many quarries located in Rockport. It would require five million tons of granite to complete. Capstone headers weighing 20 to 30 tons each topped the breakwater. Its construction began in 1885 and would result when completed in the second-largest man-made harbor in the world (Cherbourg, France, being the largest), extending 9,000 feet long and standing 22 feet above mean low water and 30 feet wide on top.

During this period, town, state, and federal officials encouraged the US Navy to visit Rockport with some of its most impressive naval vessels. The aim was to demonstrate to the world that this giant breakwater was good for the country's transportation and defense needs. So began an era in which hundreds of naval vessels began annual visits to Rockport.

Although there were 21 annual visits by over 100 ships of the US Navy up to 1919, there were three visits that were particularly notable during the years—1899, 1902, and 1906. These annual visits incorporated maneuvers at sea, target practice, and sham battles and many land-side events, like dinners, dances, and sporting events taking place around Rockport. In 1906, a fleet of 35 ships spent three months in Rockport. Thousands of people came to view the scene. Some 5,000 men were aboard these vessels, duplicating the population of the town. Participant vessels from Teddy Roosevelt's Great White Fleet visited often before and after their around-the-world tour.

Work on the breakwater continued until 1915, when the project was abandoned by the federal government as the age of sail was ending and the faster more maneuverable steam ships prevailed and the need for this harbor of refuge was considered unnecessary.

After 1919, only single naval vessel visits continued annually up until 1950. Most recently, the tradition was rekindled with visits in 2007 and 2008 by the frigates USS *Boone* and USS *John L. Hall*. In 2007, a new annual tradition was established with visits by the midshipmen of the US Naval Academy, arriving each July with a squadron of 44-foot sail training vessels to interact with the residents of Rockport just as their forebears did in the early 1900s.

One

A National Harbor of Refuge of the First Class
1880

Cape Ann, the northernmost promontory of Massachusetts Bay and located at the southern end of Ipswich Bay, juts out into the Atlantic Ocean like a huge fist. Many low-lying islands and shoals surround its outer shores, making Cape Ann a serious hindrance to coastwise navigation. It is the site of scores of terrible shipwrecks, and some would submit that it is one of the infamous "Graveyards of the Atlantic." During the 18th and 19th centuries, this section of New England coast was so dreaded by mariners sailing between Boston and ports in New Hampshire, Maine, and the Maritime provinces beyond that they routinely gave it an extra-wide seaward berth.

Herman Babson wrote the following in the October 1894 issue of *New England* magazine:

> It is estimated that more than seventy thousand vessels pass Cape Ann yearly. It is a rare occurrence when, standing on Pigeon Hill, on the northeastern part of the cape, one cannot count on a clear day from 25 to 100 coasters, bound to or from the ports of Maine, New Hampshire, or the Provinces. Then, too, the constant going and coming of the Gloucester fishing craft causes the horizon always to be dotted with white sails.

The idea of a harbor of refuge began as far back as 1830. The concept that Rockport would be a most desirable place was because it had deep water within the bay, a good anchoring ground, and, above all, alleviated the lack of a large harbor between Portland and Boston, where vessels could find shelter during storms. These facts and others led to the hope that in time a breakwater would be built across the mouth of the bay. Finally, around 1880, interest in the project gained ground, and the Sandy Bay Harbor of Refuge became a common topic of conversation. Congress ordered the chief of engineers of the US Army to survey the bay, beginning in 1882, to determine Sandy Bay's suitability as a "national harbor of refuge of the first class."

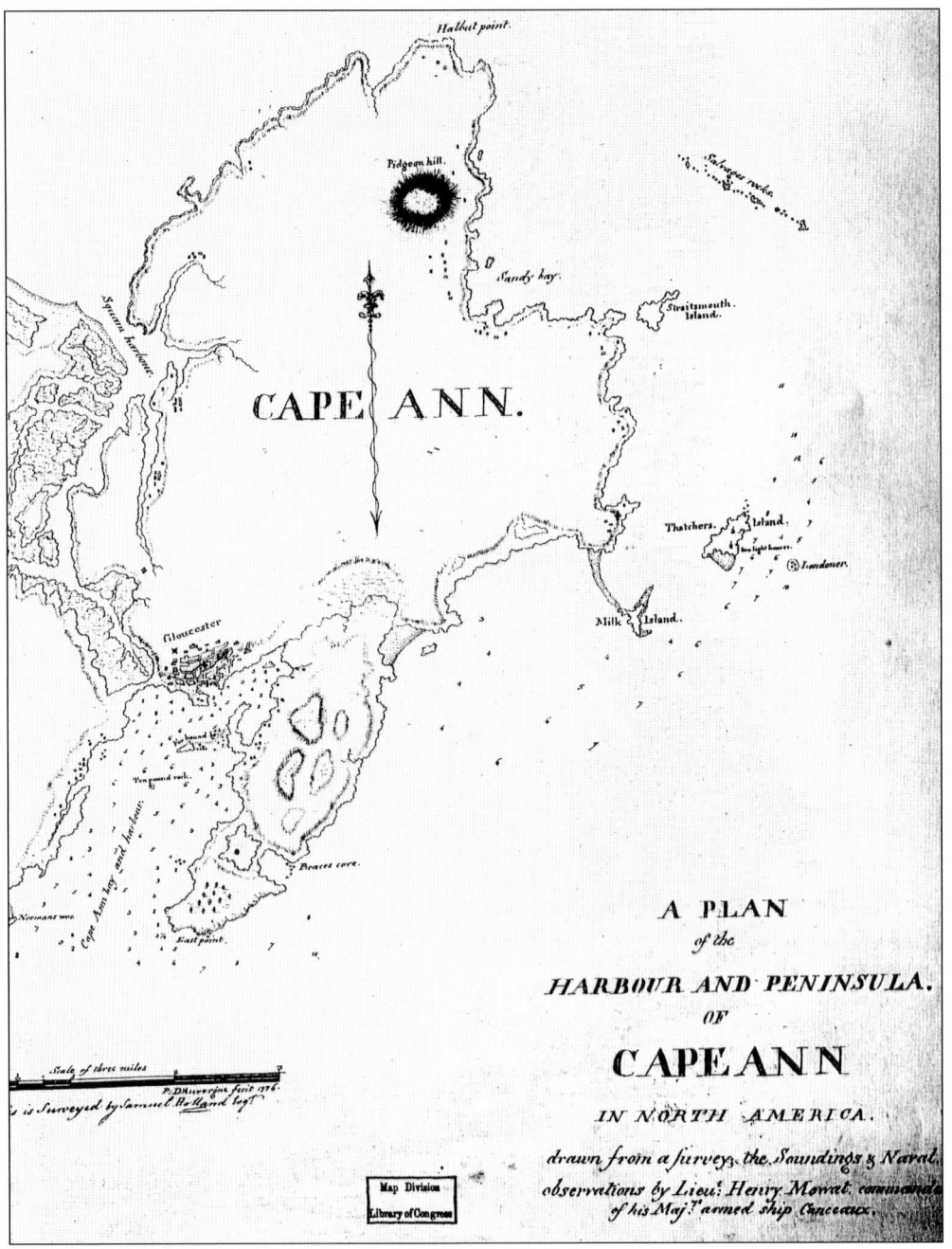

Sandy Bay is located at the northeastern extremity of the promontory of Cape Ann, which forms the northern limit of Massachusetts Bay. It is bounded by Straitsmouth Island on the east and Andrews Point on the northwest. It is about 2 miles wide between Andrews Point and Straitsmouth Island and about 1.5 miles long to its head at Rockport Harbor. By water, Sandy Bay is about 9 miles northeast of the entrance to Gloucester Harbor, 23 miles north of Boston Harbor, and 24 miles south of Portsmouth Harbor. The rocky shores of Sandy Bay are indented by three small harbors: Rockport Harbor, Gull Cove, and Pigeon Cove—the largest of which is Rockport Harbor. (SBHS.)

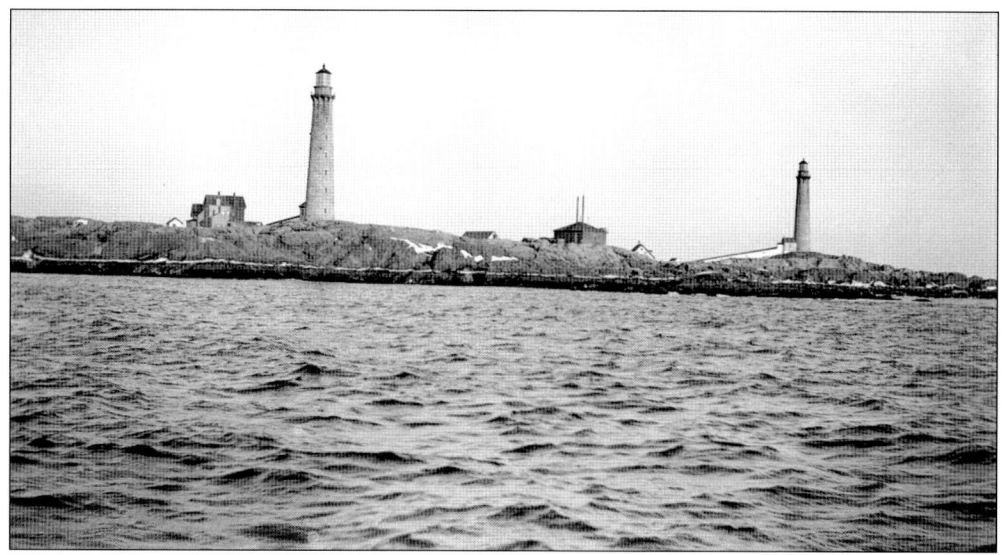

The federal government recognized the dangers in this area and established six lighthouses within a six-mile radius of one another. Two of these, the well-known "Twin Lights" of Thacher Island, situated one mile due east of Cape Ann, were often the first land sightings of vessels making transatlantic crossings destined for Boston. (Author's collection.)

The Massachusetts Humane Society, the predecessor of the US Life-Saving Service and, later, the US Coast Guard, established two lifesaving stations on Cape Ann. One was in the large fishing port of Gloucester and the other in Rockport, the small town that sits on the eastern edge of Cape Ann. Prior to these, it had established five lifesaving huts and lifeboat sheds from Rockport to Gloucester. (Author's collection.)

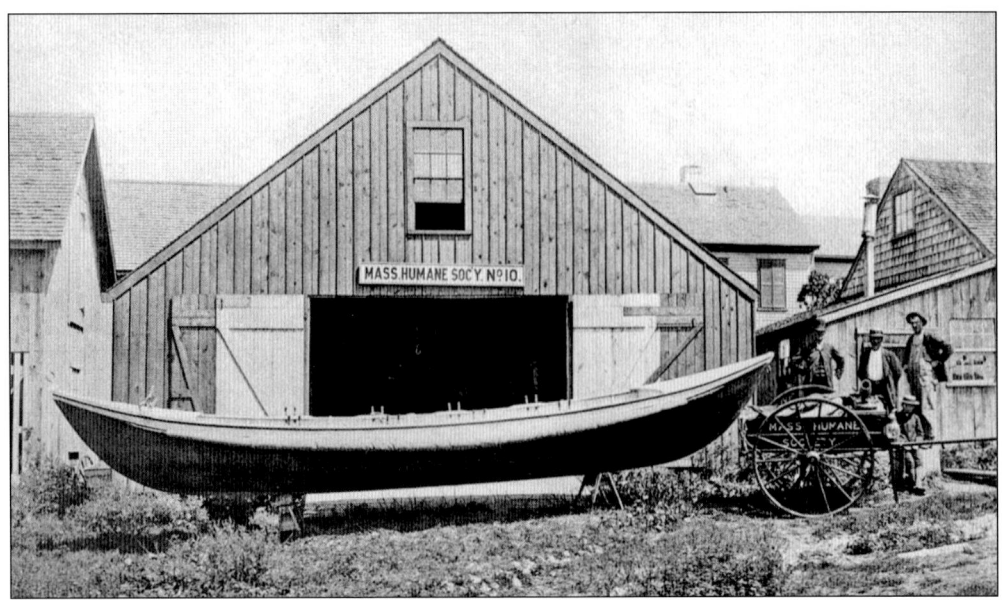

The Massachusetts Humane Society built boats and boathouses along the Massachusetts coast. In Rockport in 1858, there was Lifeboat and Mortar Station No. 3 on Bearskin Neck, operated by Capt. John B. Parsons. There also was a surfboat station on Emerson Point, operated by Asa Todd, as well as a hut of refuge on Milk Island, operated by William Stillman in 1869. (SBHS.)

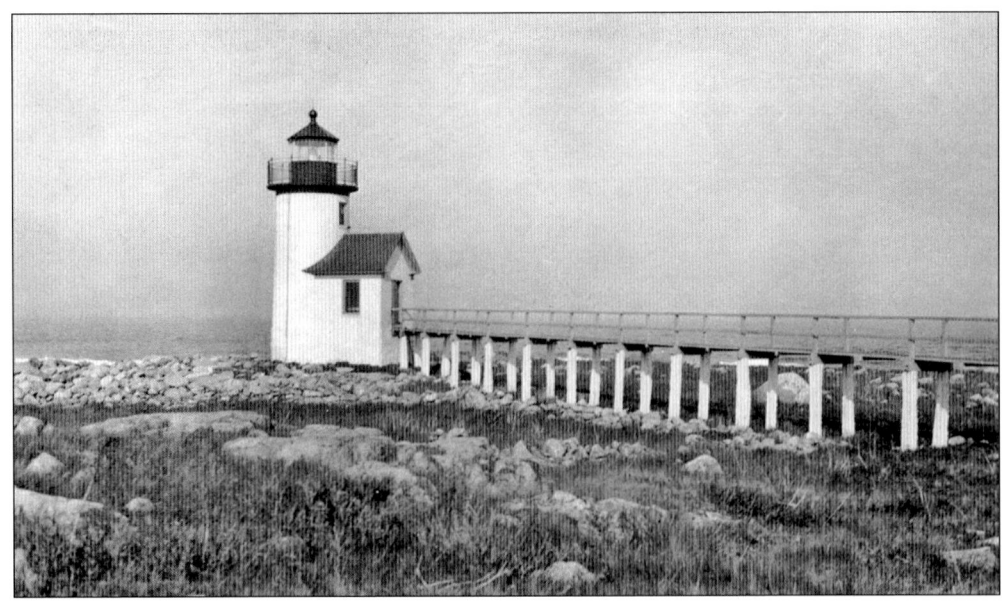

Straitsmouth Light Station was built in 1835 to mark the entrance to Rockport Harbor as well as guide the many "rock sloops" that passed by to pick up granite from the burgeoning granite quarries along the Cape Ann coast. Granite became a bigger industry than fishing in the 1850s to 1920s. (Author's collection.)

A Sandy Bay Harbor of Refuge Committee of 12 members was formed in 1880 to examine the need for a safe harbor for vessels passing by Sandy Bay; it made its report public in 1886. This committee was made up of marine underwriters, members of chambers of commerce, merchants, ship owners, pilot associations, customs officers, Army engineers, marine societies, and shipping interests from the Atlantic ports. The report states, "The immense commercial interests of Boston alone demand of the national government greater protection than is at present afforded, such protection in fact as can be given by the rapid completion of this harbor of refuge at the very entrance to Boston Bay." It goes on to list the hundreds of wrecks occurring since 1828 "in the immediate vicinity, and which could have been prevented, had a commodious harbor, ease of access, been located at this point, as the proposed one at Sandy Bay will prove to be." (SBHS.)

Congress directed the chief of engineers of the US Army to conduct a more extensive survey of Sandy Bay to determine its suitability as a "national harbor of refuge of the first class." Once again, examiners found it "worthy of improvement." Secretary of War Robert T. Lincoln (the late president's eldest son) transmitted the report to Congress, and on July 5, 1884, the project was signed into law. (LOC.)

The schooner *Harriet* is fetched up on the beach in Folly Cove, Rockport, on March 28, 1895. She was carrying stone, and her home port was Gloucester. Folly Cove is located to the north of Thacher Island on Cape Ann near Sandy Bay. (SBHS.)

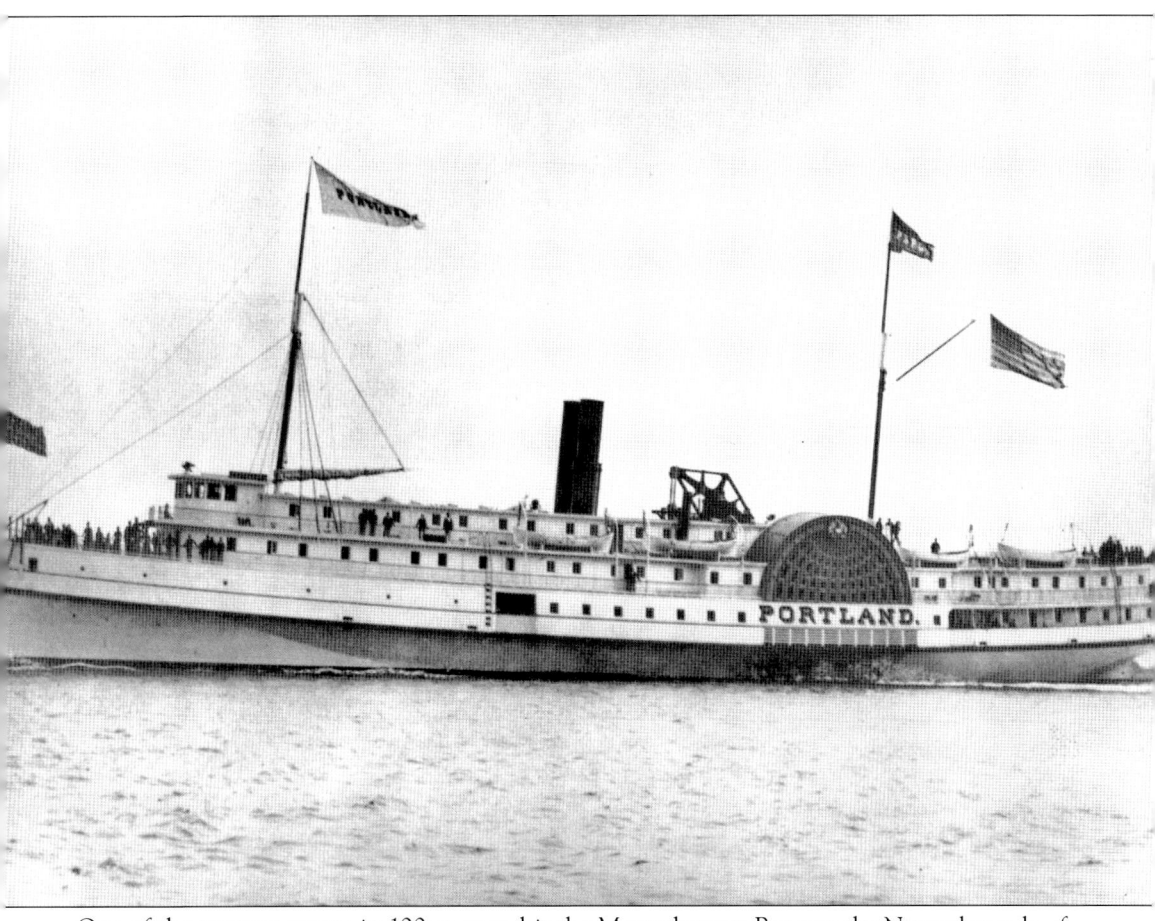

One of the greatest storms in 100 years to hit the Massachusetts Bay was the November gale of 1898, dubbed the "Portland Gale." The wooden-hulled side-wheeler steamship SS *Portland* was last seen at 9:30 p.m. on November 27 by keeper Albert Whitten; she was off Thacher, near the Londoner Reef, heading south. It sank with all 192 passengers and crew lost. The tragedy was later called the "*Titanic* of New England." Charles Libby, representing the owners of the ill-fated *Portland*, wrote an impassioned plea for support of the project. He cited the tragic sinking in the "hurricane" and he provided evidence "that if this harbor of refuge existed it could have been easily reached by the steamship . . . and that she would have been saved." The wreckage was discovered in 2002 on Stellwagan Bank in 460 feet of water, not seven miles from Thacher Island, although wreckage was found as far south as Provincetown on Cape Cod. (SBHS.)

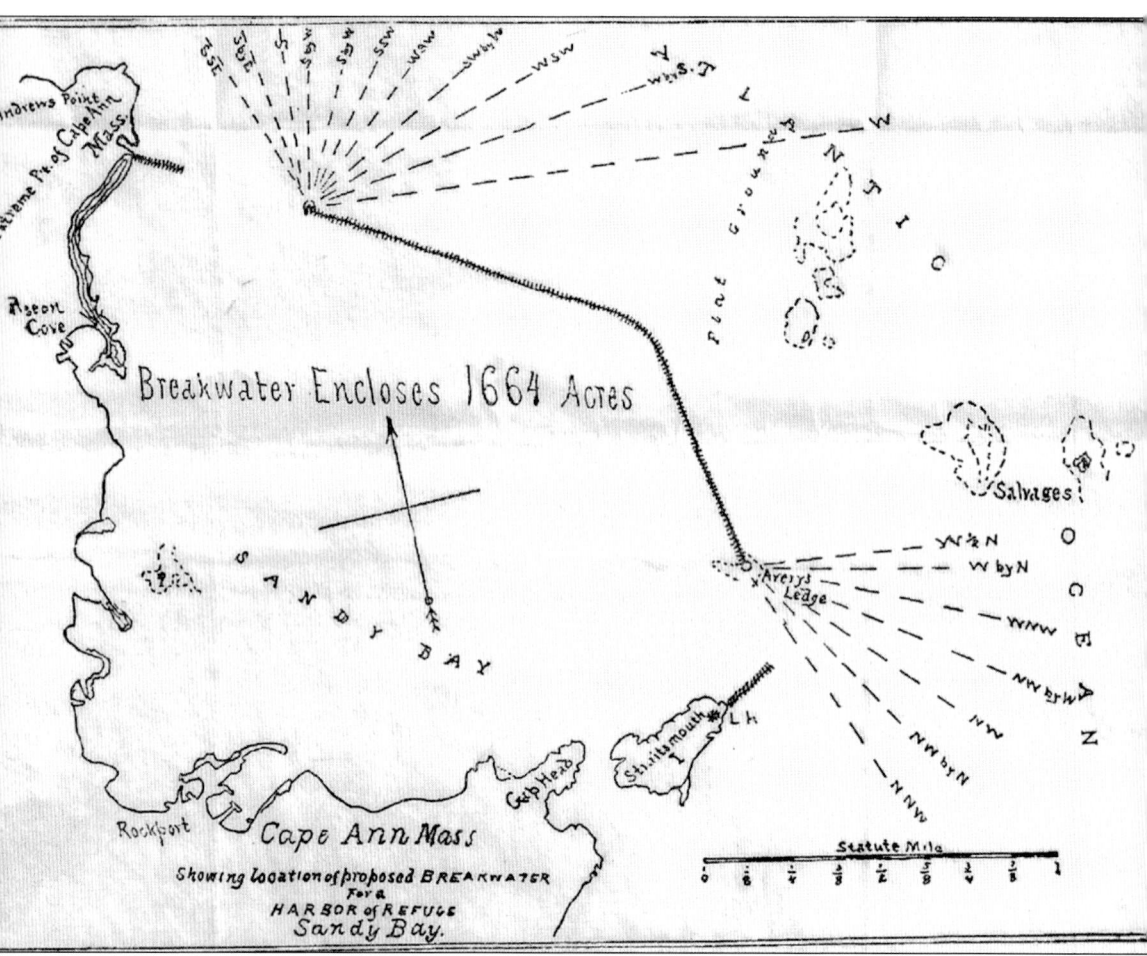

This map accompanied the Sandy Bay Harbor of Refuge Committee Report of 1886. Notes with the map state the following: "The National government is now building a breakwater to partly close the seaward opening and thus enclose a large harbor of more than sixteen hundred acres, leaving two openings, each of which is to be much wider than that of any other port on our coast. No harbor would offer more advantages than this. It is reached easily by all vessels bound to or from the coast of Maine, New Hampshire or the Provinces; they would in all cases of stress of weather have fair wind to its shelter, free of bars or obstructions or intricate channels. There is never any ice in the bay; there is excellent holding ground found at the bottom, and it has a large extent of deep water (from fourteen to sixty feet), giving ample room to avoid crowding and to get underway." (SBHS.)

"The fact that more than seventy thousand vessels must pass here annually in prosecution of their voyages is impressive, and accounts for the increasing interest manifested by ship owners, underwriters, masters, and mariners. The partial lists of wrecks subjoined to this writing is a painful record," the committee report goes on to say. From 1874 to 1883, there were 98 wrecks and 374 partial wrecks recorded in this area. (SBHS.)

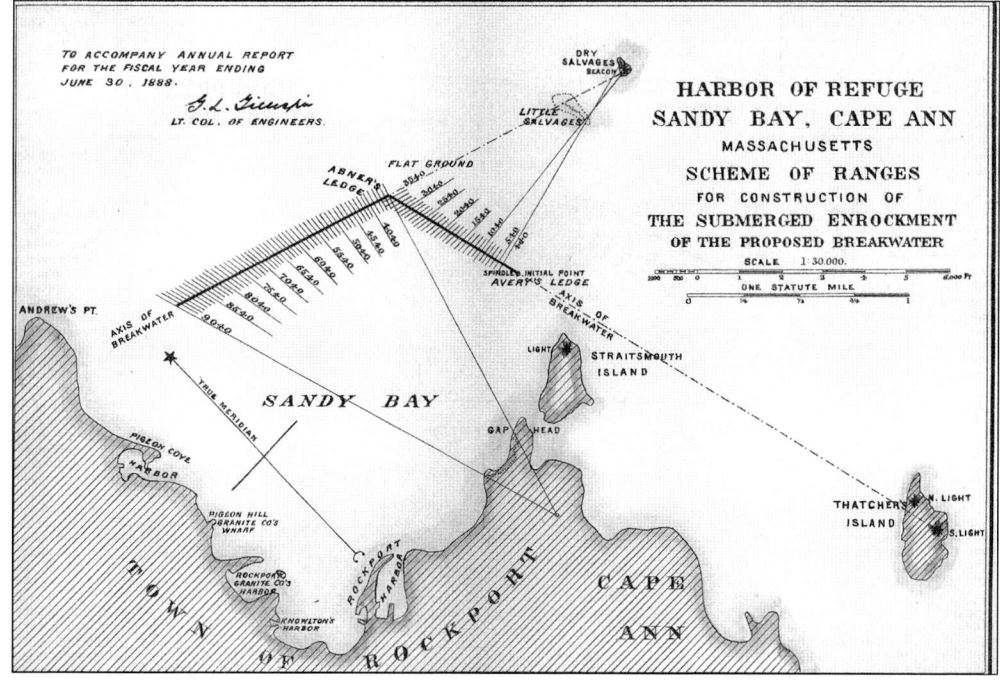

This map from the US Army Corps of Engineers annual report of 1888 shows the measurements and location of the breakwater. The original project was authorized by the River and Harbor Act of 1884 and proposed a continuous breakwater, 9,000 feet long, divided into two branches. One branch starts at Avery's Ledge and runs 3,600 feet to Abner's Ledge; the other extends 5,420 feet from Abner's Ledge in a northwesterly direction and terminates off Andrews Point. (SBHS.)

PROPOSALS FOR THE DELIVERY OF RUBBLE-STONE FOR HARBOR OF REFUGE,
Sandy Bay, - - - Cape Ann, Mass.

ADVERTISEMENT.

UNITED STATES ENGINEER'S OFFICE,
P. O. Box 5346, Room 124, P. O. BUILDING,
BOSTON, MASS., SEPTEMBER 4, 1886.

SEALED PROPOSALS, in triplicate, will be received at this office until 12 o'clock noon of Wednesday, Oct. 13, 1886, for the delivery of 150,000 tons of rubble-stone, more or less, required for the Harbor of Refuge, Sandy Bay, Cape Ann, Mass.

For specifications, blank forms, and all information, apply to the undersigned.

G. L. GILLESPIE,
Major of Engineers, Bvt. Lt. Col. U. S. A.

SPECIFICATIONS.

It is proposed to construct, under the available appropriation, a portion of the substructure of the breakwater for the Harbor of Refuge, at Sandy Bay.

Quantity. — The quantity of stone called for is 150,000 tons, of 2000 lbs. each, more or less; the exact quantity to be contracted for will depend upon the price.

Quality. — The stone must be of the best quality as regards strength and durability; granite rubble-stone is preferred.

Size. — One-fourth of the stones must weigh not less than four (4) tons each; one-half must average two (2) tons each; and one-fourth must weigh from 1000 to 50 lbs. each.

The shape of the blocks must be angular and as nearly cubical as practicable, the smallest dimension to be not less than one-third of the greatest; it is understood that the quality, size and shape of the stone must be satisfactory to the United States Engineer in charge.

Character of Work. — The stones must be deposited in the breakwater, in extension of the work now being done by contract. The present contract is expected to complete the substructure of the breakwater for a distance of about 1282 feet from the initial point on Avery's Ledge, and the stone now called for will be applied in

This 1886 ad appeals for 150,000 tons of "rubblestone" for the breakwater of Sandy Bay Harbor of Refuge. The definition of a harbor of refuge is given as "an artificial harbor, prepared at the expense of the General Government, capable of affording refuge and shelter to many vessels, great and small, at the same time. This refuge and shelter referring to dangers from storms, actual or impending, as well as from hostile ships in time of war." (SBHS.)

[FORM 19 a.]

ARTICLES OF AGREEMENT

Entered into October 21st, 1886, between Lt. Col. G. L. Gillespie, Corps of Engineers, of the one part, and the Rockport & Pigeon Hill Granite Companies, of the other part, for Rubble Stone for Harbor of Refuge, Sandy Bay, Cape Ann, Mass.

Here is the articles of agreement between the government and Rockport Granite Company and Pigeon Hill Granite Company. The agreement states, "Parties agree to furnish all requisite plant and labor, and deliver and place in a position in the substructure of the proposed breakwater for the Harbor of Refuge at Sandy Bay, Cape Ann." In the first of many contracts, the companies agreed to furnish 128,000 tons of stone at 58.3¢ per ton. (SBHS.)

Two

Building a Breakwater
1884

The Sandy Bay Harbor of Refuge was to be the second-largest harbor in the world. As a safe haven for mariners escaping the vicious nor'easters and hurricanes that frequent this stretch of Massachusetts coast, it could have sheltered thousands of vessels at one time. However, only a small fraction of it was ever completed. It was a major federal project that became obsolete during its 30 years of construction. Still, its long, tumultuous history provides an uncommon but fascinating look into US maritime heritage at the dawn of the steamship age, a century ago. From 1885 until 1916, over two million tons of stone were placed. The construction of a great breakwater to form a harbor was at best a costly undertaking, and only the inexpensive and abundant supply of material from Rockport's 60-plus quarries nearby rendered such a work economically possible. The original project was authorized by the River and Harbor Act of 1884 and proposed a continuous breakwater that was 1.5 miles long and divided into two branches. The federal government's Board of Engineers concluded the project could be completed in 10 years at a cost of $4 million, with annual appropriations of $400,000. The project design was modified in 1892 and again in 1900, which changed the amount of grout used for the substructure and the height below mean water. This increased the estimated costs to over $6 million. Unfortunately, the initial appropriation by Congress was a meager $100,000. Subsequent funding for it in the years to come saw similar small appropriations, and the time to complete stretched far beyond the original estimate.

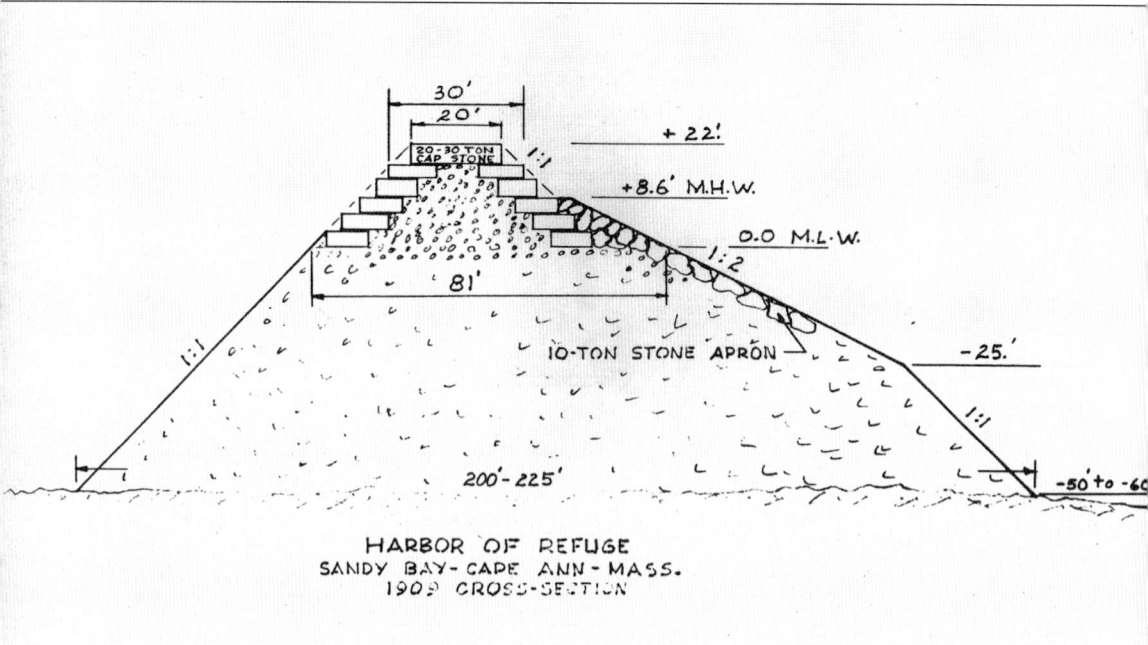

HARBOR OF REFUGE
SANDY BAY - CAPE ANN - MASS.
1909 CROSS-SECTION

The Sandy Bay breakwater is known as a composite breakwater. The subsea structure (the enrockment) is constructed of loose rubble—commonly called "grout"—up to low water, upon which a sloping foundation with vertical wall is built. By this means, the wave is caused to both break and to turn to one side. The large tiered rectangular blocks of granite, called "header" stones or top capstones, are 20 to 30 tons and measure 20 feet across with a rise of five feet. These would be pinned and joined together with iron dowels and galvanized bands. The second-tier capstones reach 30 feet across. The base of the grout substructure measured 200 to 225 feet wide (depending on water depth) and peaked to about 81 feet at mean low water, upon which header stones were placed. The grade on the ocean side (right on diagram) was one to two feet, and the inshore slope (left on diagram) was to have a natural gradient of one to one. (SBHS.)

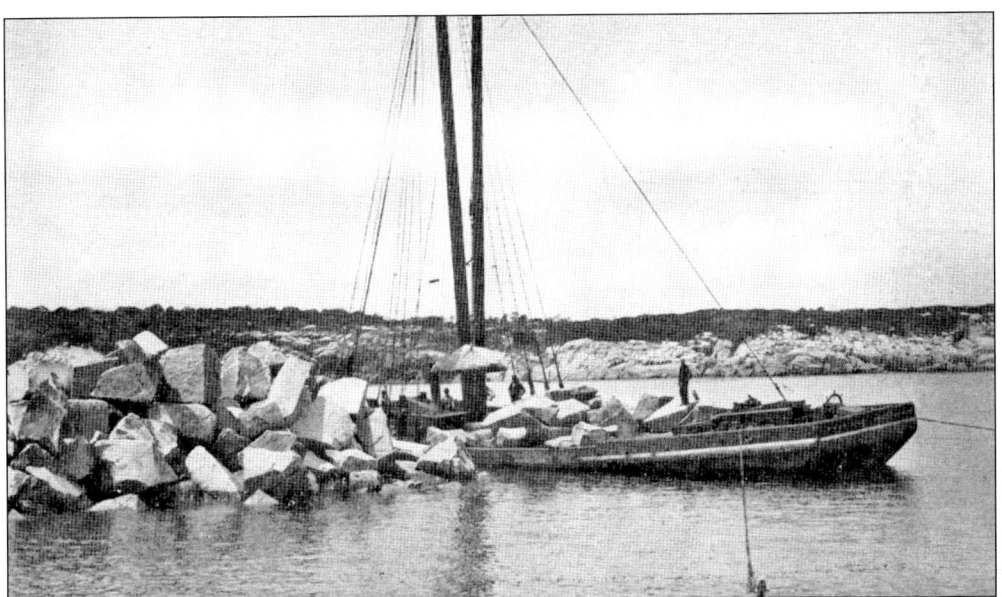

The first contract between the Rockport Granite Company and the Pigeon Hill Granite Company and Maj. Charles Raymond, US Army Corps of Engineers, was dated October 30, 1885, agreeing to supply 128,000 tons of granite grout. The Rockport Granite Company was to provide two-thirds of the grout and Pigeon Hill one-third. The first load of grout was set in place on November 12, 1885, accompanied by the shrilling sounds of steam whistles on the sloop *Screamer*. (SBHS.)

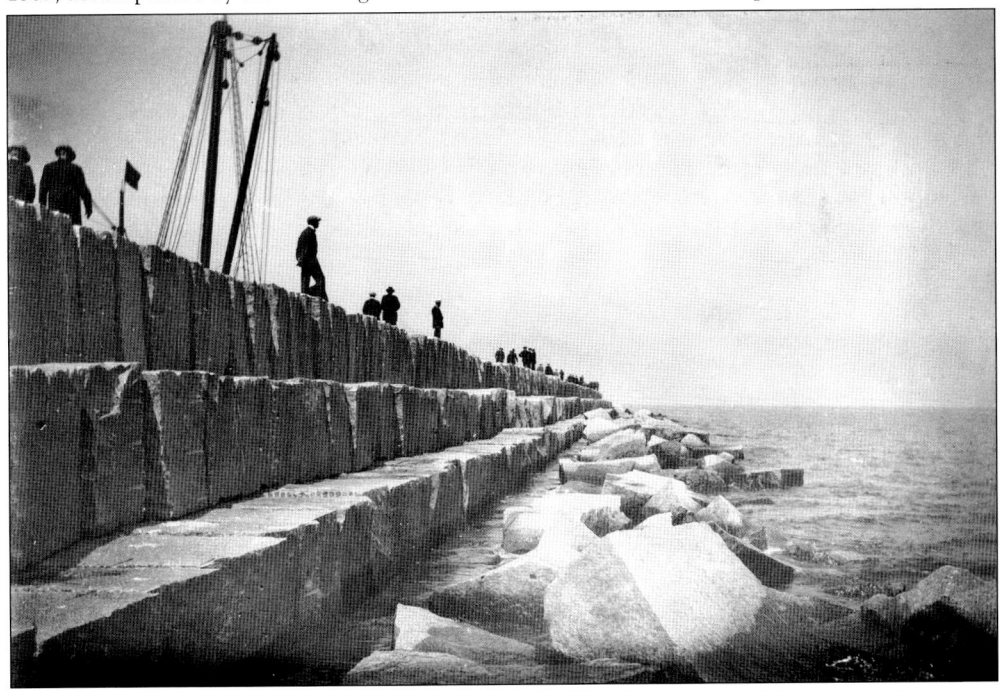

The breakwater's progress in 1914 shows three levels of header stones and the grout substructure at mean low water. Each stone weighs more than 10 tons. Note the derrick lifting mast of the stone lighter *West End* behind the breakwater. At this point, about 922 feet of the breakwater was completed. This is the southern arm heading toward Straitsmouth Island. (SBHS.)

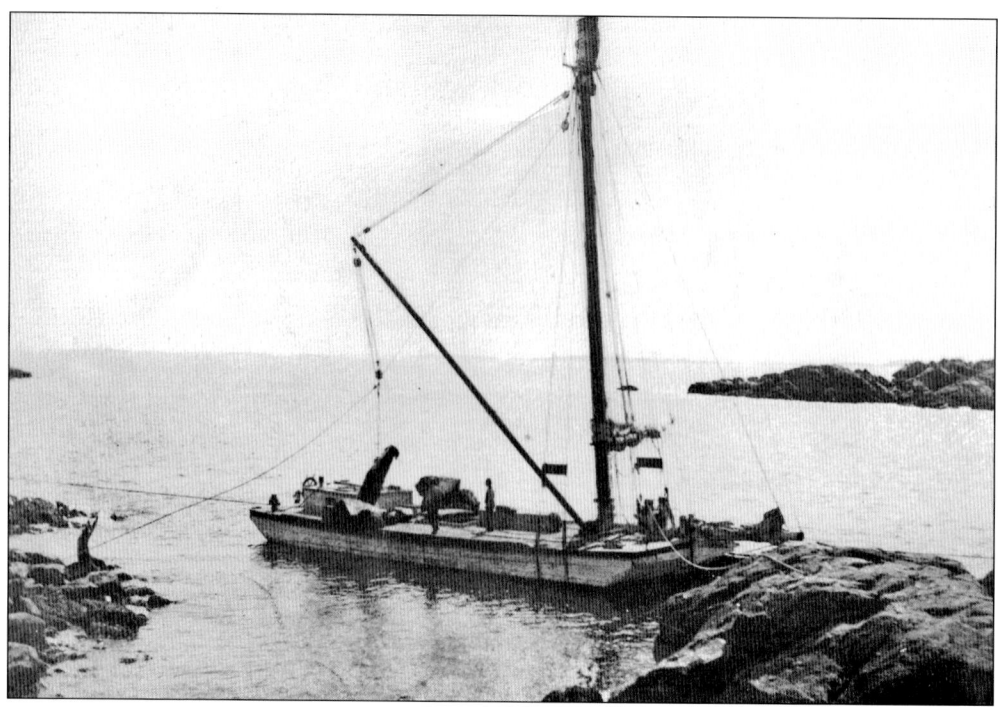

The stone sloops were of extra-heavy construction, usually oak timbered and planked, broad-beamed, and staunchly rigged. They were single stick (one mast) and had a gaff-rigged mainsail. Each carried a sturdy cargo boom, which was stepped into a saddle or block on deck at the foot of the mast. This was used to swing cartloads of dimension stone into its hold. (SBHS.)

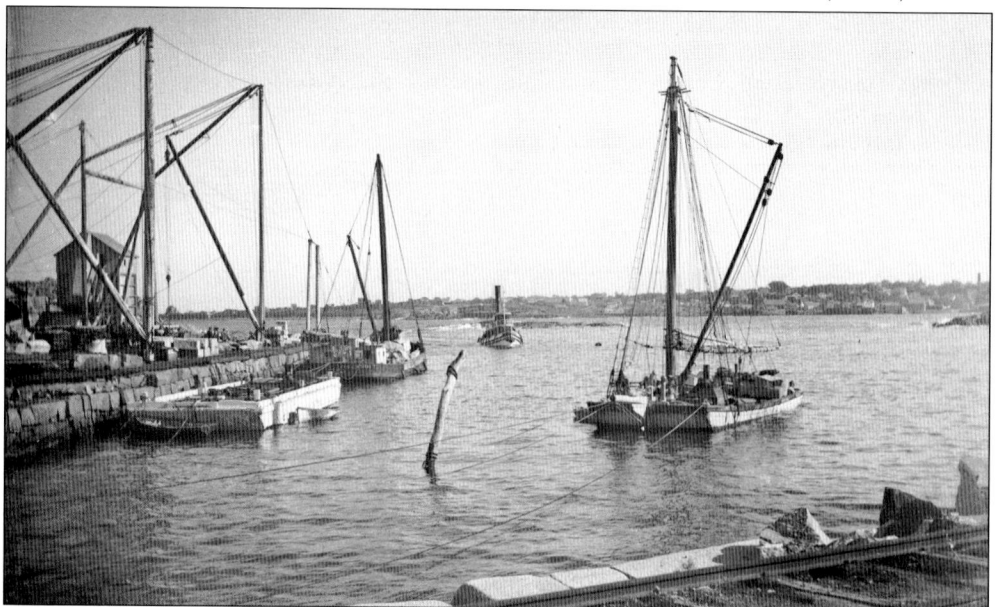

In the center is the granite sloop *Jumbo* arriving at Pigeon Cove dock to load and haul stone for the breakwater. The tug *Confidence* in the center is the on its way to pick up the self-dumping scow on the front left. The lighter ahead of the scow was homeported in Portsmouth, New Hampshire, on contract to the Rockport Granite Company. (SBHS.)

The steamer *William H. Moody* sidles up to a Rockport Granite Company self-dumping scow while building the Sandy Bay breakwater. The *Moody* was built in 1898 in Essex and was rated at 259 gross tons. The company reported in 1930 that it owned two barges, *R.G. Scow No. 1* and *Herbert*; it is unknown which is pictured. (SBHS.)

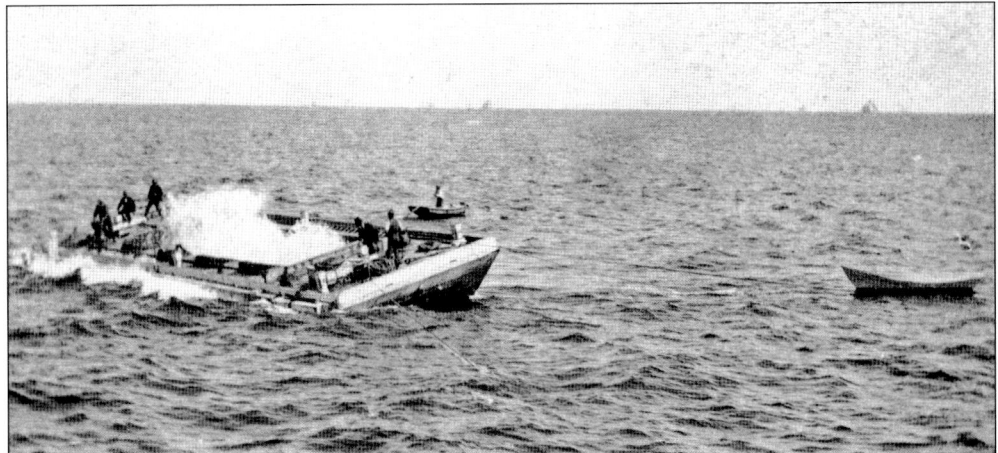

A self-dumping scow is pictured in action on the Sandy Bay breakwater in September 1891. The scow had drop-down hinged doors in its floor to release the grout to build up the breakwater base. The scow could hold 100 tons of stone. Note the marker buoy in the center that marks the exact location of the unloading point. The man in the skiff is directing operations. (CAM.)

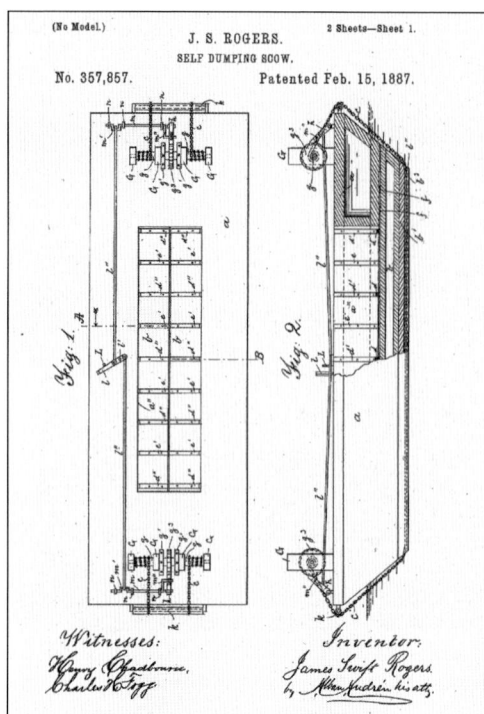
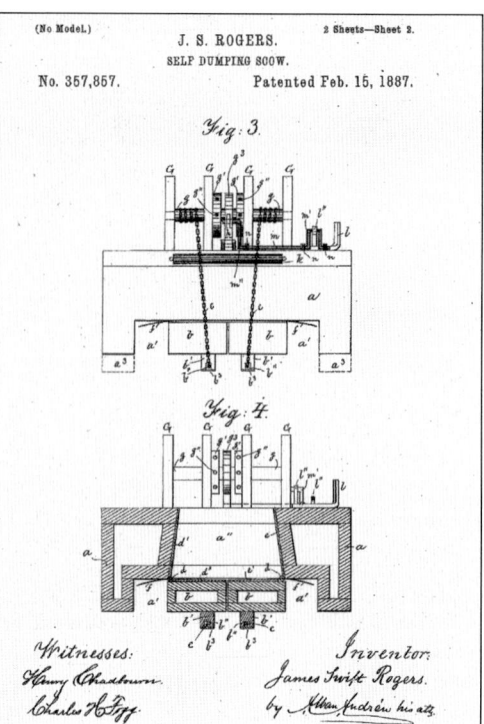

On February 15, 1887, James Swift Rogers from Rockport received a US patent for his improvements in self-dumping scows design. This copy of the patent shows the workings of a longitudinal plan view, side elevation, and the end view. The use of self-dumping scows was a boon to the granite company's ability to make the job of building the substructure more efficient and faster. (Google Patents.)

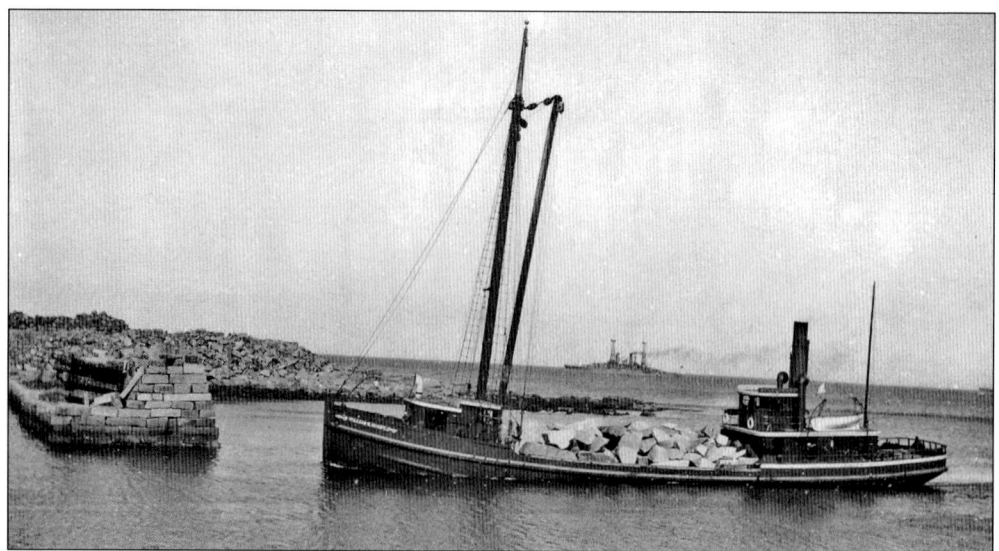

This is an interesting photograph of the *William H. Moody* entering the harbor at Pigeon Cove with a load of grout. Note the battleship in the center distance steaming north. This was one of the North Atlantic Fleet's vessels that came to Rockport each summer for naval exercises. They came to publicize and encourage the building of the 5,000-ship harbor of refuge breakwater. (SBHS.)

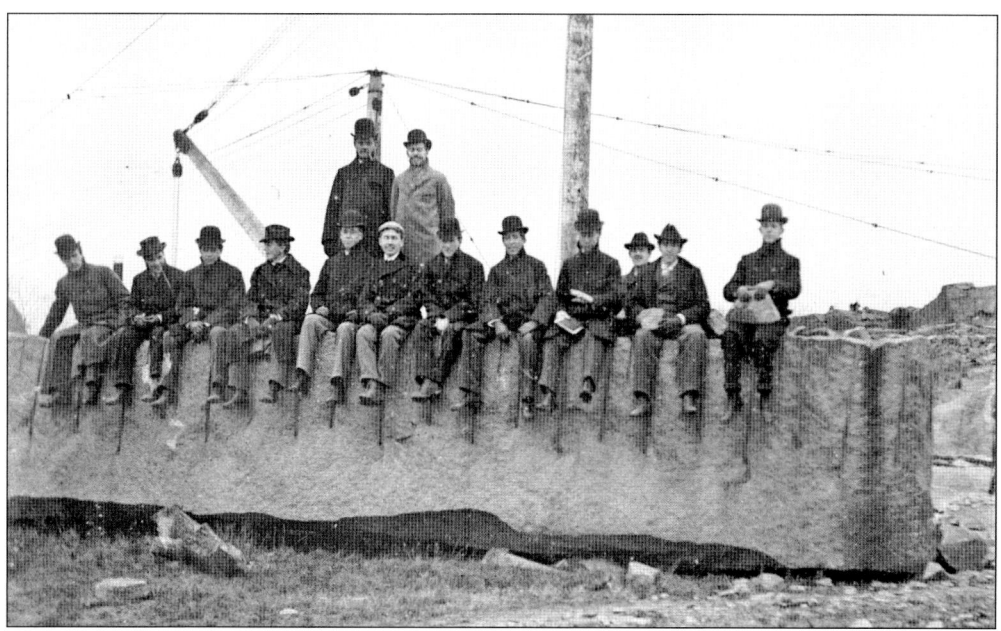

These gentlemen are sitting on a huge piece of Rockport granite used for the harbor of refuge breakwater in 1898. The 14 men provide a graphic visual as to the size of the header stone used to top off the breakwater. A cubic foot of Rockport granite weighs 168 pounds. Based on the size of this block, it weighs approximately 30 tons. (SBHS.)

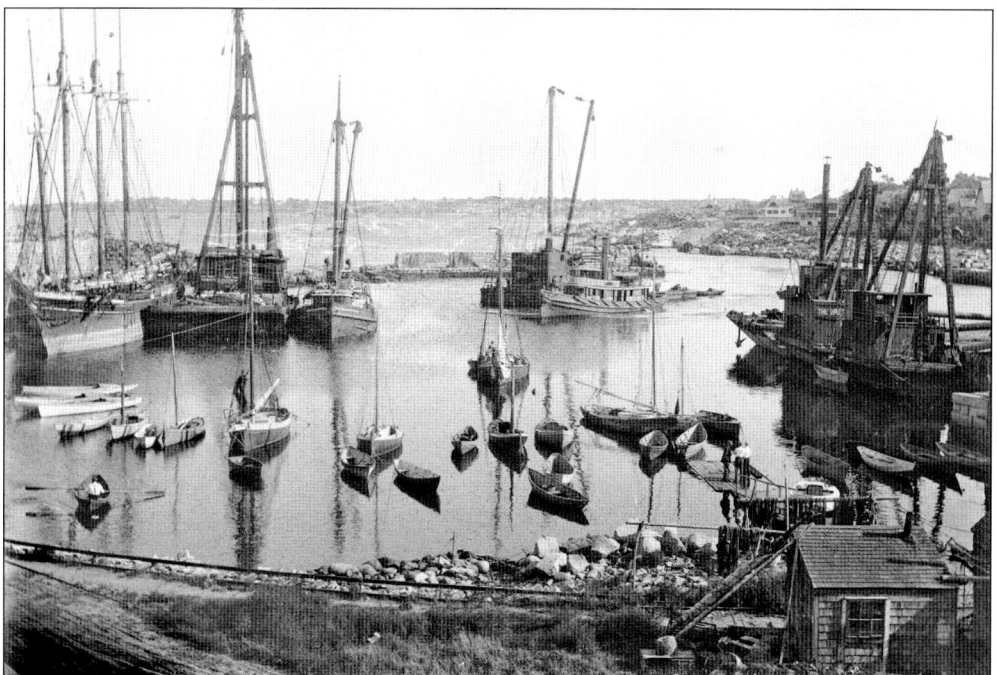

In Pigeon Cove harbor this day, the tug *Confidence* on the right is bringing in a lighter. In the center is the steam lighter *William H. Moody*, and to its left is the barge *Commander*. To the left of that is the four-mast granite schooner *General Adelbert Ames*. There are four steam-driven cranes in this photograph used for lifting granite blocks onto the breakwater substructure. (SBHS.)

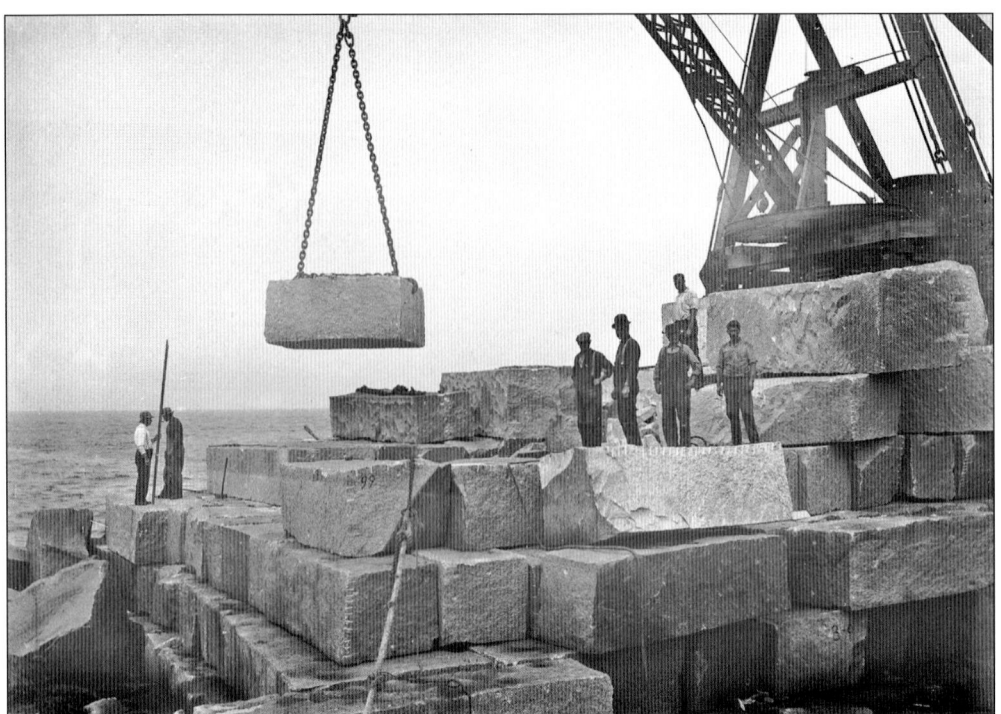

Here, a barge derrick lifts granite blocks, weighing more than 30 tons each, onto the breakwater. It was originally estimated that over 1,000,000 tons of granite were to complete the breakwater. Cost estimates had escalated from $4 million to over $6 million since its start in 1885. By 1916, some 2,133,734 tons of granite had been placed, at a cost of $1,941,479. (SBHS.)

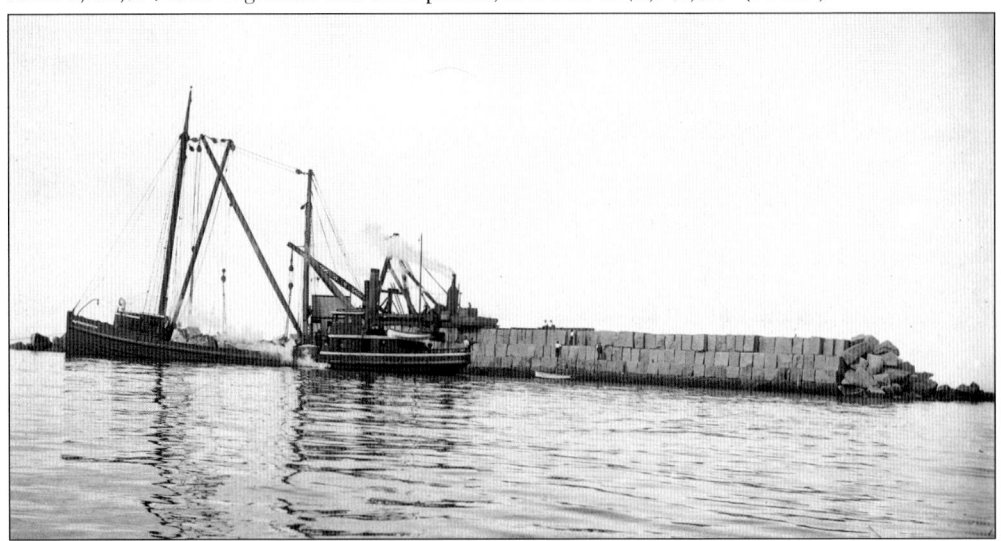

A lifting scow and granite lighter are constructing the breakwater in 1900. The harbor of refuge was to consist of a V-shaped granite block wall extending one mile northwest toward Andrews Point and southerly about three-quarters of a mile toward Thacher Island and Avery's Ledge. The harbor would have enclosed 1,664 acres and was designed to hold 5,000 ships. It was to be situated in an area where over 147 total wrecks and 560 partial disasters occurred between 1874 and 1894. (SBHS.)

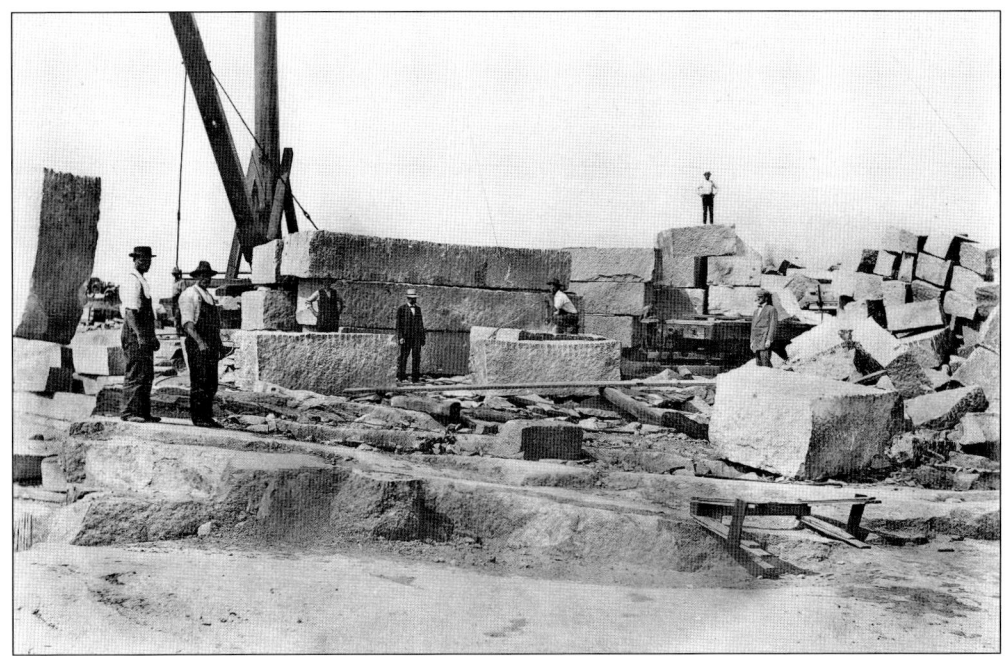

Babson Farm Quarry workers are cutting giant blocks of granite for the capstone of the Sandy Bay breakwater. The man on top of the block in the center is operating a plug drill, which he uses to split the block in half. (SBHS.)

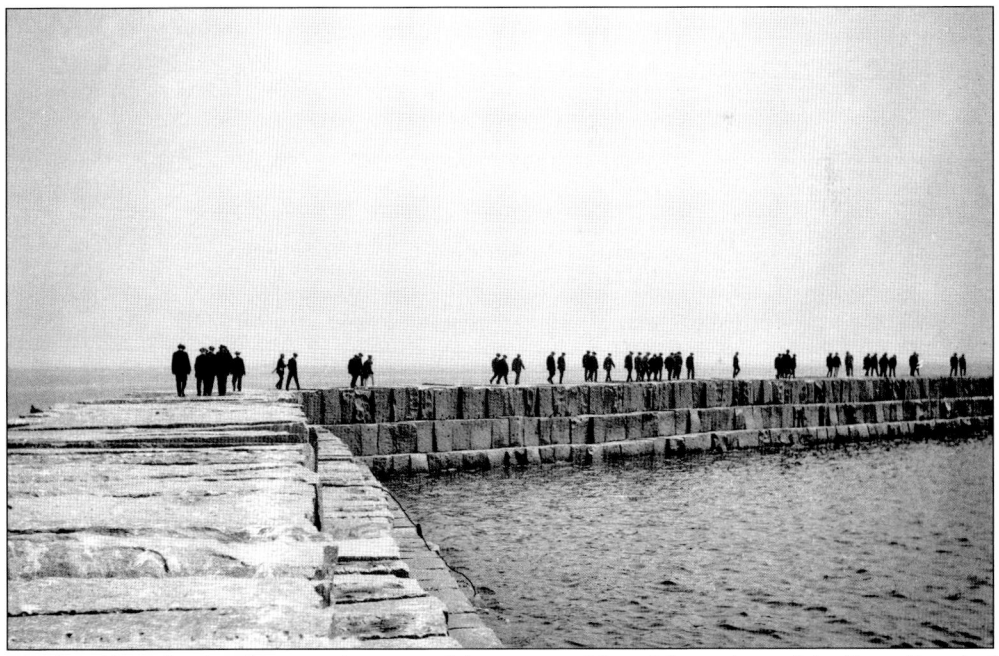

The local boards of trade were advocates of this project. Here, 25 members of the Essex Board of Trade are inspecting the first finished portion of the breakwater in July 1915. This shows the dogleg turn of the breakwater at Abner's Ledge; the end facing is headed toward Andrews Point, while the other piece to the right is aimed toward Straitsmouth Island and Avery's Ledge. (SBHS.)

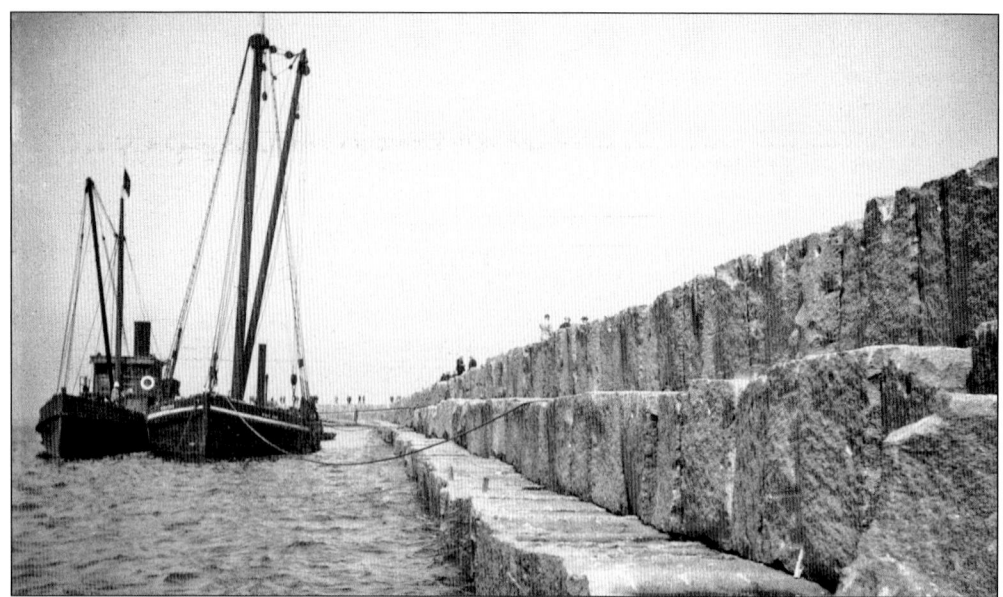

The rock ship *West End* is tied next to the *W.H. Moody*, the lighter used to bring large blocks of granite to the work site. On this day, *Moody* also ferried the board of trade members out to the breakwater from Granite Pier in Rockport, which was only a 20-minute boat ride. (SBHS.)

The Lighter *Commander* lifts a 20-ton granite header block and carefully places it on the top layer of the breakwater. The tug *Confidence* keeps her close to the wall. Note the "dog hooks" at the end of the chain used to lift the block. Holes are drilled in each end for the hooks to grab like a pair of tongs. Blocks were pinned with iron dowels and two-inch iron straps. (SBHS.)

Three

Ships of the Line, the Navy's First Visit
1899

The first of the Navy's many visits to Rockport and the future harbor of refuge came on July 8, 1899, when the North Atlantic Squadron made up of the battleships *Massachusetts*, *Texas*, and *Indiana* along with the armored cruisers *New York*, *Brooklyn*, and *New Orleans* arrived in Sandy Bay. Having recently fought in the Spanish-American War in Cuba in July 1898, these ships were well known to everyone. The ships had just completed a victory tour in New York Harbor in December 1898. They celebrated their one-year anniversary in Rockport.

These were the first all steel-hulled and steam-powered coastal defense battleships, all built within the decade. The *Texas* was the sister ship of the USS *Maine*, which had been sunk in Havana Harbor in February, precipitating the war. Now, all were here in Rockport to display their power. This chapter describes the ships, the men, and detail events during their visit. This was the beginning of annual summer visits by the North Atlantic Fleet until the start of World War I.

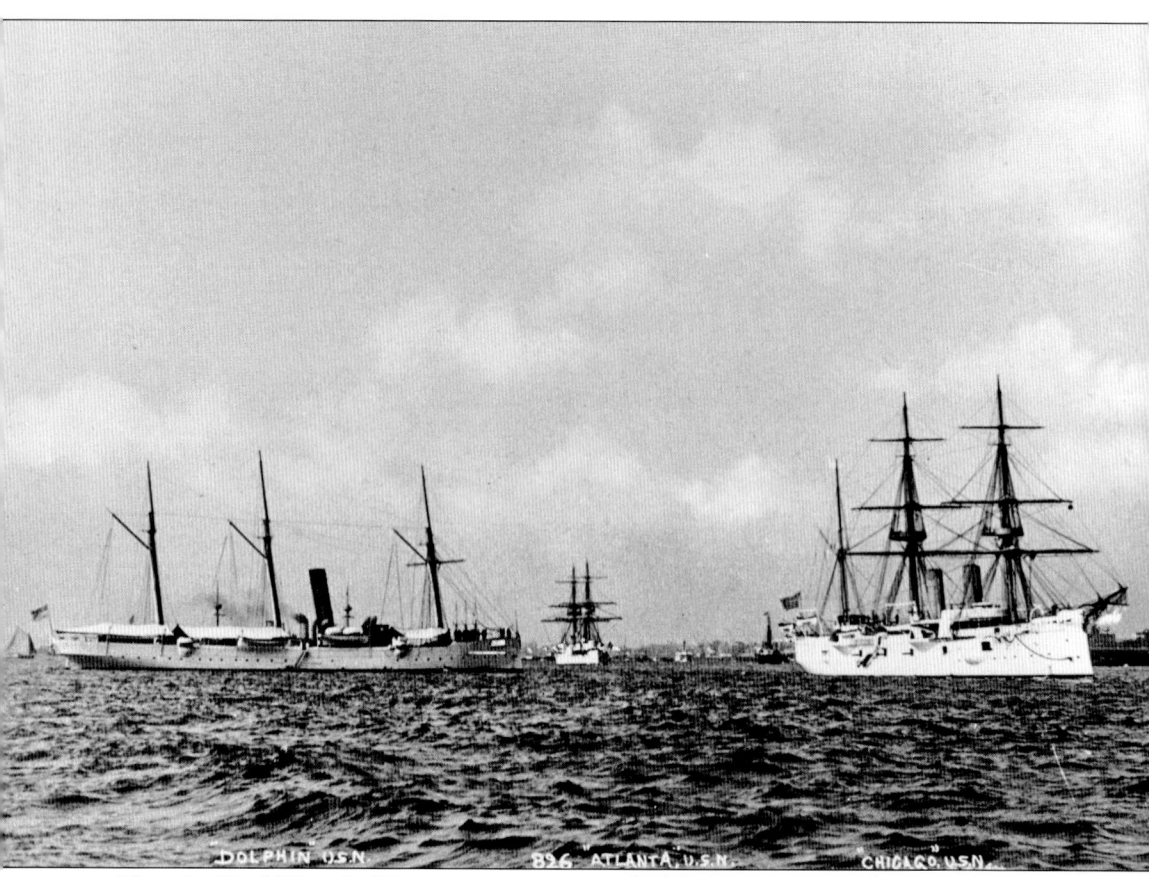

After the Civil War, the Navy went into a period of decline. By 1880, the Navy had only 48 ships in commission and 6,000 men. Congress authorized the construction of three protected cruisers—USS Atlanta, USS Boston, and USS Chicago—along with a dispatch vessel, USS Dolphin, together known as the "ABCD" ships. Shown here are, from right to left, USS Dolphin, USS Atlanta, and USS Chicago. These were all steel-hulled ships powered by a combination of sail and steam. They were the first to transition from wood to steel hulls and to use breech-loading guns. Congress also authorized the construction of the first battleships of the Navy, USS Texas and a new USS Maine (replacing the one sunk in Havana Harbor). This was the beginning of the "New Navy." Between 1895 and 1910, twenty-nine battleships were added to the fleet. Today, the Navy has 430 ships on active duty around the world along with over 324,000 active duty officers and enlisted. (NHHC.)

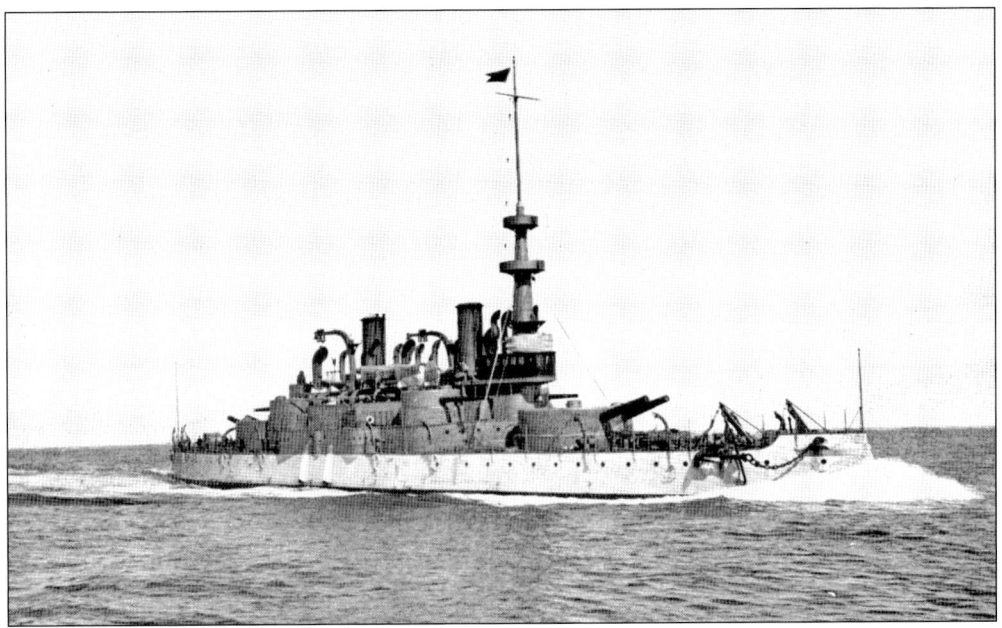

US naval visits to Rockport's Sandy Bay Harbor were encouraged to demonstrate that this breakwater was good for the country's commerce and defense needs. On April 26, 1896, the newly built USS *Massachusetts* held her initial speed trials on Cape Ann, starting at Thacher Island and running 31 miles north to Cape Porpoise, Maine, and back to Thacher. *Massachusetts* broke all records, running at 16.4 knots per hour. (SBHS.)

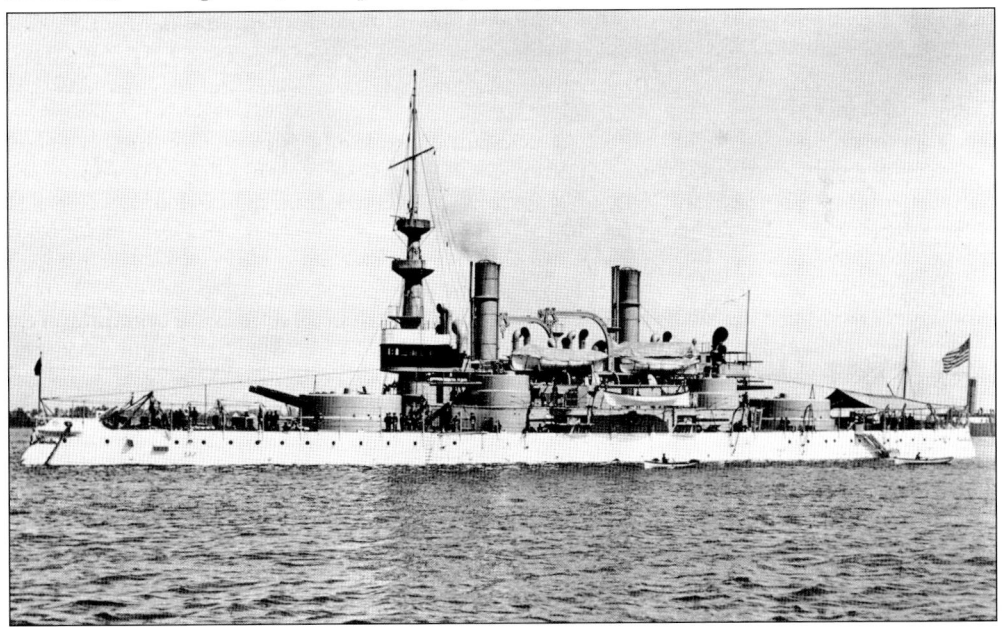

On July 8, 1899, the North Atlantic Squadron made up of the battleships *Indiana*, *Massachusetts* (shown here), and *Texas* and the armored cruisers *New York*, *Brooklyn*, and *New Orleans* arrived in Sandy Bay Harbor. Having recently fought in the Spanish-American War in Cuba, these ships were eagerly welcomed by the populace. The ships displayed their pennants and signal flags and at night performed spectacular searchlight shows for the townspeople. (SBHS.)

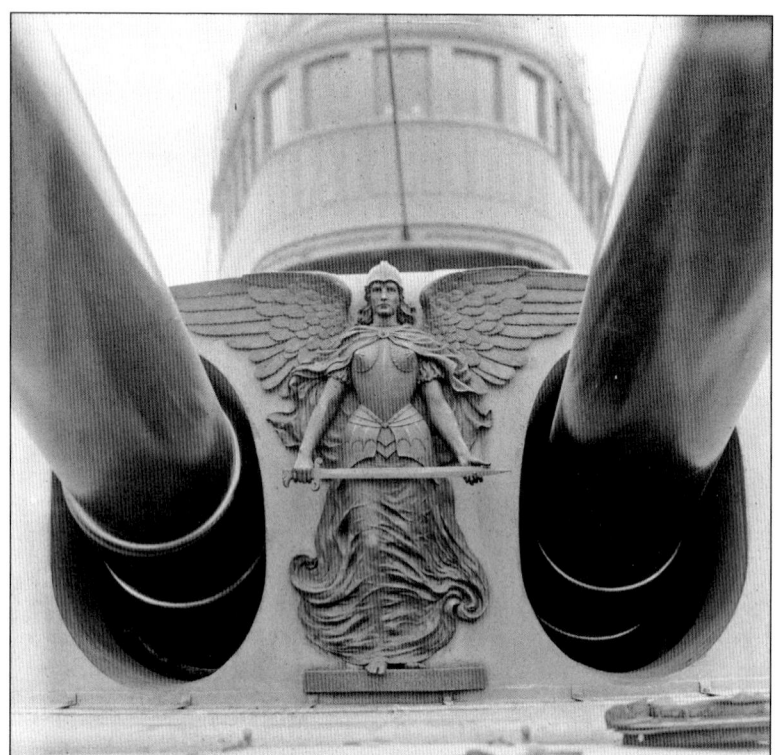

This *Winged Victory* figurehead is mounted on the forward turret between the 13-inch guns of the USS *Massachusetts*. It was sculptured in bronze by Bela Lyon Pratt. The plaque reads; "By Duty Done Is Honor Won." It stands 5.5 feet high and, from wing to wing, is 7 feet wide. It now hangs in Dahlgren Hall of the US Naval Academy. (LOC.)

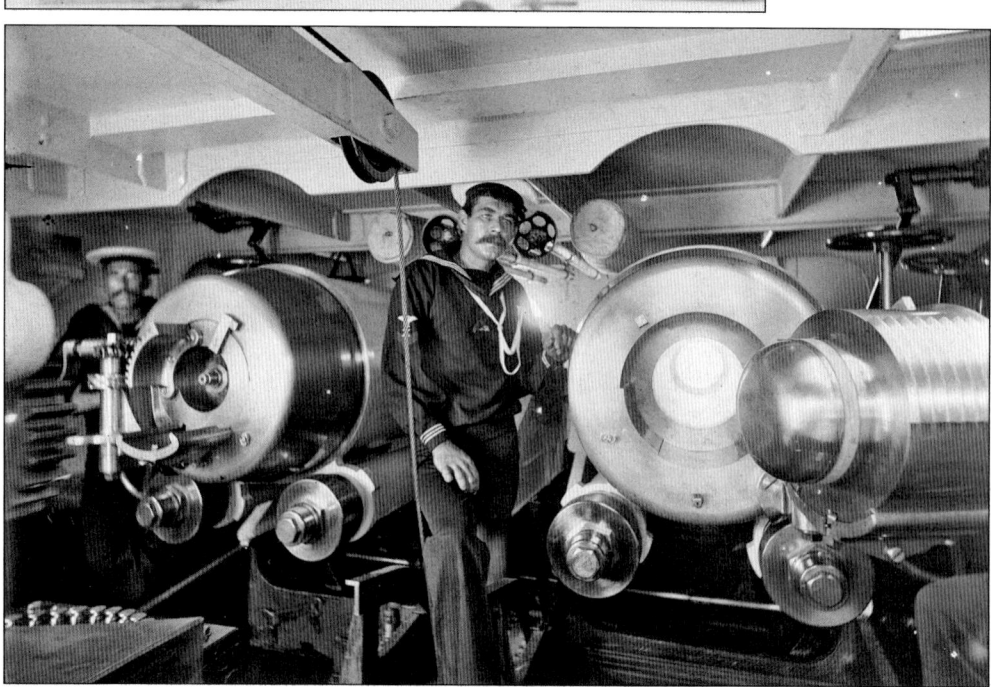

Pictured is the inside of the forward 13-inch gun turret with the breech door open ready to receive the charge and the projectile (shell). *Massachusetts* was armed with two twin 13-inch, four twin 8-inch, and four 6-inch guns. The turret was protected by **15-inch-thick** armor plate made of nickel steel. The eight-inch turrets had six-inch armor. (LOC.)

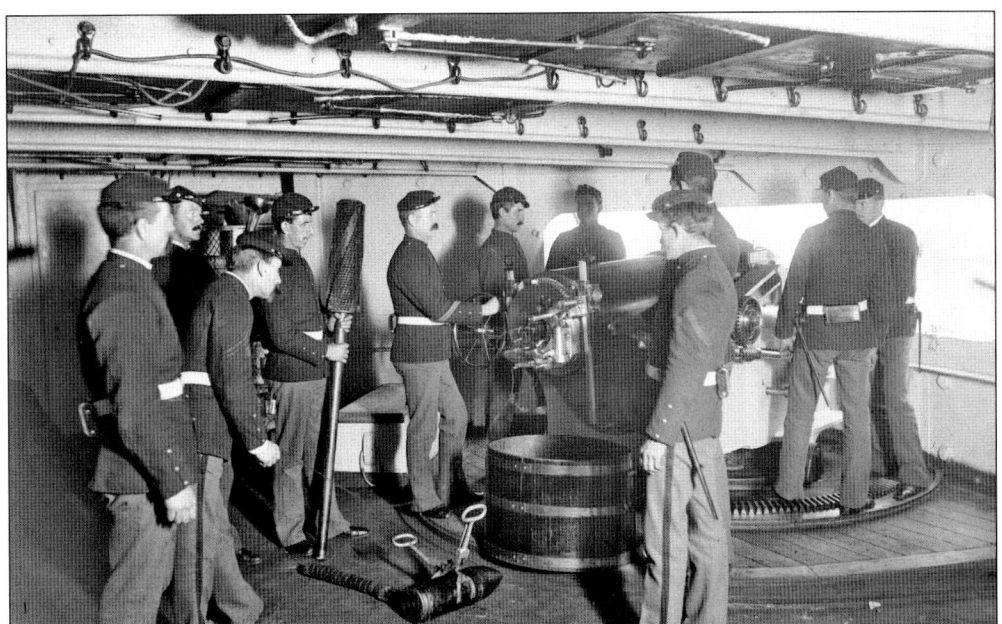

The USS *Massachusetts* was armed with four 6-inch, .40-caliber Mark 4 guns that used black powder. In later years, these guns were replaced because they were not considered strong enough to withstand the higher chamber pressures generated by the new smokeless powder. It fired 105-pound naval armor-piercing shells and had a range of 9,000 yards. Note the shell with "ice tongs" to lift it into the breech. (LOC.)

A four-man gun crew prepares to fire the six-pounder, one of 20 mounted around the *Massachusetts*. In total, she had 54 guns plus four 18-inch torpedo tubes. (LOC.)

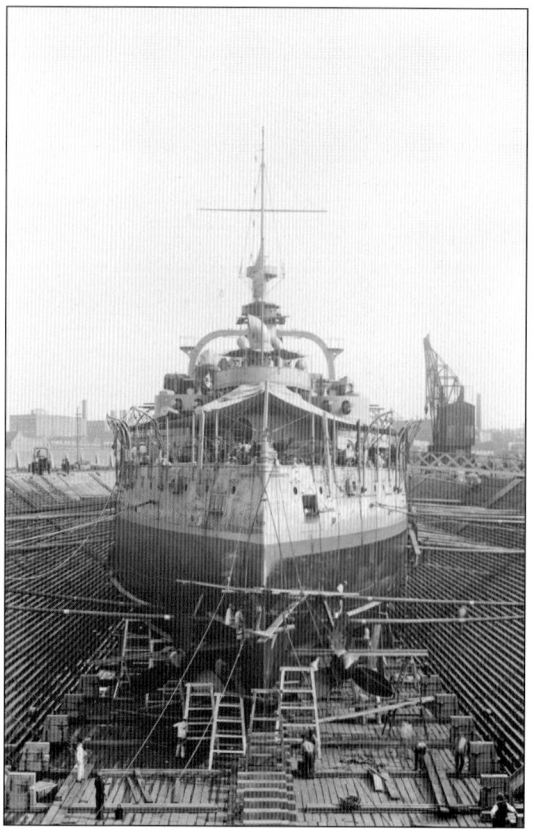

USS *Massachusetts* may have been the worst-designed battleship in the history of the Navy. She was only the second of the "modern" battleships but was obsolete five years after her launch. She was one of the unluckiest as well. While leaving New York Harbor in 1898, she struck Diamond Reef, flooding five of her forward compartments. In March 1901, she grounded again in Pensacola, Florida. During target practice in January 1903, an explosion in her eight-inch turret killed nine crew members. In August of the same year, the ship grounded on a rock in Frenchman Bay, Maine, taking in 140 tons of water from a foot-long gash. Another lethal accident took place in December 1904; three men were killed and several others badly burned when a steam gasket burst. By 1920, she was used as a target ship for experimental artillery and scuttled in shallow waters off Pensacola in January 1921. She is now part of the Florida Underwater Archaeological Preserve and, in 2001, was added to the National Register of Historic Places and serves as an artificial reef and diving spot. (Both, LOC.)

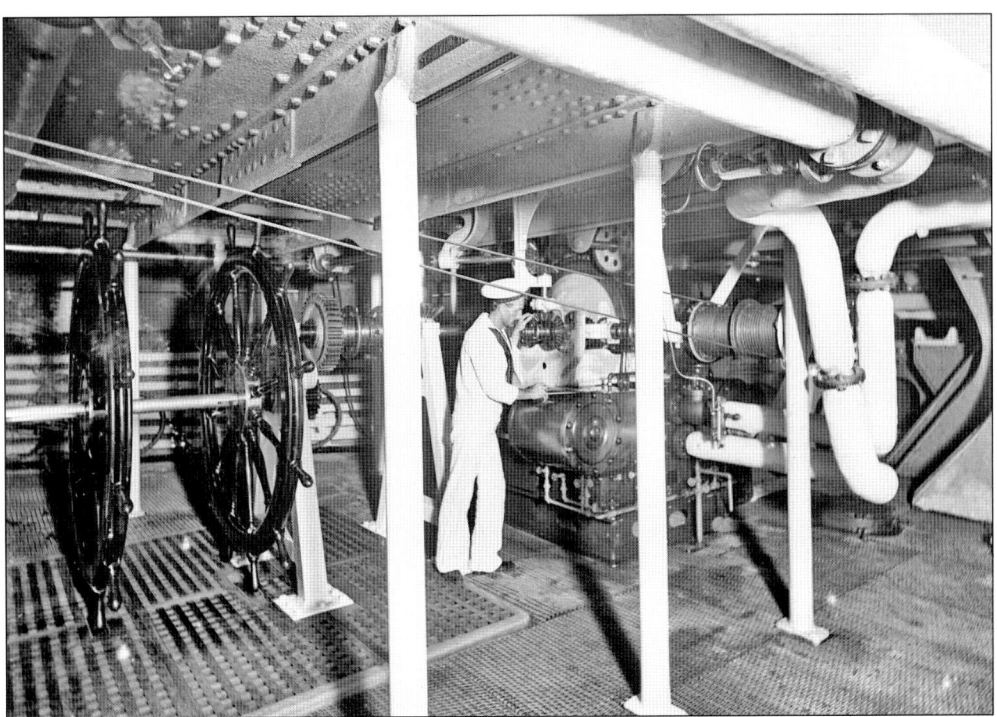

USS *Massachusetts* steam steering gear belowdecks shows the interesting gearing and cable system that is connected to the standard double ship's helm wheel, which operates the rudder. (LOC.)

USS *Indiana* arrived at Rockport commanded by Capt. Henry Clay Taylor, who oversaw the squadron in the temporary absence of Rear Adm. William Sampson. She had a complement of 685 enlisted men and 42 officers. *Indiana* was the first of the steel battleships to be built. As the sister ship of the USS *Massachusetts*, she had similar specs, with a displacement of 10,288 tons and total length of 351 feet. (NHHC.)

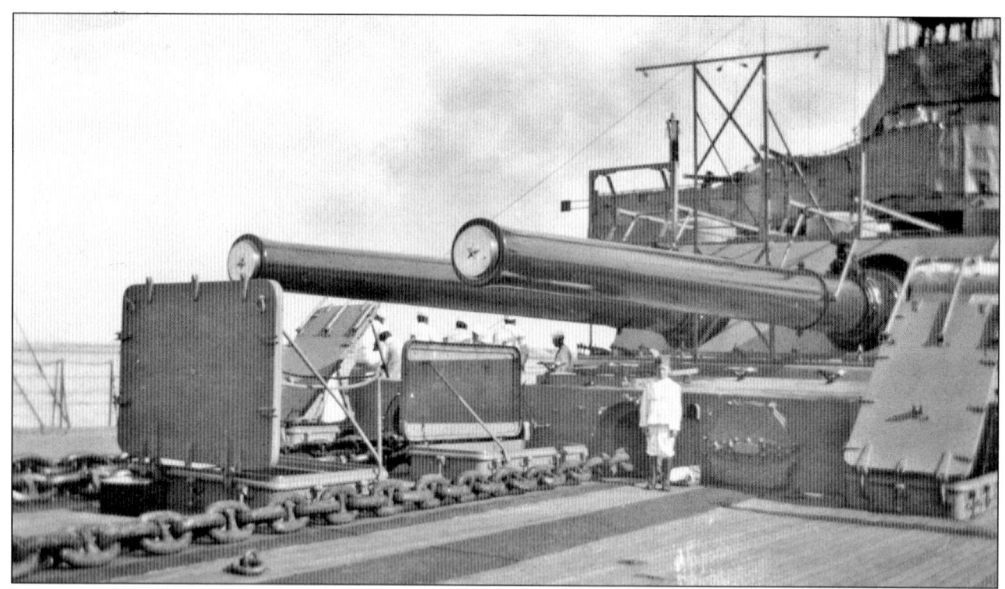

On board the battleship *Indiana*, a young man has his picture taken in front of the giant 13-inch guns. Commissioned November 20, 1895, she was commanded by Capt. Robley D. Evans and spent her entire career in the Atlantic. During the Spanish-American War, she participated in the naval battle off Santiago, Cuba. *Indiana* was decommissioned in January 1919 and used as a target in ordnance tests, being sunk in November 1920. (SBHS.)

Here, crewmen are standing atop *Indiana*'s forward portside eight-inch gun turret, in the late 1890s. This ship had four twin eight-inch turrets on both port and starboard sides. This was an 8-inch, .35-caliber Mark 3 gun, which fired a 260-pound projectile that could hurl a shell 16,000 yards. Crews could get a shot off every 120 seconds. (NHHC.)

The entire crew is pictured here on the fantail of the USS Brooklyn; they are surrounding the aft gun turret with its two eight-inch guns. Her complement was 561 officers and enlisted. Note the triple helm just beyond the turret and the two rowing lifeboats hanging in their davits with the initial B on the bow. (LOC.)

Crewmen of the USS Brooklyn pose with the ship's goat mascot. The ship fought bravely in the Battle of Santiago de Cuba during the Spanish-American War and served as the flagship of the Flying Squadron under Comdr. W.S. Schley. She was struck 20 times in the battle and suffered only one wounded and one man killed. (LOC.)

Brooklyn Sailors and Their Mascot Goat who Fought at Santiago.

Coalers are feeding one of *Brooklyn*'s five double-ended boilers that provided steam to the four, vertical triple-expansion reciprocating engines, which develop over 16,000 horsepower. Her top speed was 21.9 knots (about 25.2 miles per hour), which she did on her trial. (LOC.)

The gun crew of the *Brooklyn* is engaged with two of the ship's 12 six-pounder Driggs-Schroeder breech-loading rapid-fire rifles. Note their uniforms are reminiscent of uniforms worn in the Civil War period. (LOC.)

USS *Brooklyn* had its own shipboard tailor. He was an important crew member doing the tailoring for the 560-person crew. Sailors of the time were often nicknamed "Jackies," referring to the old-time "Jack Tar" reference from the Royal Navy during the period of the British Empire. This came from when wooden sailing vessels soaked their rigging in tar to prevent rot. Sailors "tarred" their clothes to waterproof them. (LOC.)

USS *Brooklyn* had a main armament of eight 8-inch Mark 3 breech-loading rifles in four twin turrets in a "lozenge" arrangement (two forward and aft and two port and starboard). The forward and starboard side turrets were electric powered, while the other two were steam powered. Her "belt" armor was three inches thick (all around the hull to a depth of eight feet). (NHHC.)

USS *Texas* was a 6,315-ton second-class battleship, built in Norfolk Naval Shipyard and commissioned in August 1895. During the Spanish-American War, she was active off the coast of Cuba and participated in the Battle of Santiago on July 3, 1898. After the war, *Texas* was the flagship of the Coast Squadron. The ship was renamed *San Marcos* in 1911. (NHHC.)

Texas armament included two 12-inch guns, six 6-inch guns, and twelve 6-pounders. The gun crew stands behind a supply of 12-inch shells. Photographer Edward H. Hart did hundreds of photographs for the Detroit Photographic Company between 1895 and 1901. (LOC.)

With her complement of 30 officers and 362 enlisted men, she served almost 19 years cruising Atlantic and Gulf Coast ports. *Texas* participated with the Flying Squadron to blockade the Cuban coast. When the Spanish fleet tried to escape from Santiago Harbor, she immediately took four of the enemy ships under fire. (LOC.)

Here, *Texas* gun crews are manning a pair of Driggs-Schroeder one-pounders in the fighting top. Ammunition is swung up by a whip reeved through the small davit. (NHHC.)

Built in Philadelphia and commissioned in August 1893, USS New York was an 8,150-ton armored cruiser. She originally served as flagship of the South Atlantic Squadron but joined the North Atlantic Squadron as flagship when the Spanish-American War began in 1898. In 1917, she was renamed USS Rochester and operated mainly in Chinese waters. She was scuttled in December 1941 to avoid risk of capture by the Japanese. (NHHC.)

USS New York flies the flag signaling cease firing at the end of the Battle of Santiago de Cuba on July 3, 1898, outside of Havana Harbor. She was 384 feet long with an armament consisting of six 8-inch, twelve 4-inch, and eight 6-pounders. She was the first of the armored cruisers to enter the US Navy service. (NHHC.)

The *New York*'s six-inch gun crew readies for the next salvo. See the shell with its "ice tongs" used to lift it into the gun. The wheel on left elevates the gun. Two men use the ram to push the shell and bag of black powder into the gun breech. The wooden bucket under the gun is filled with sand to accept gunpowder residue and shell fragments after each firing. (LOC.)

Ralph E. Sampson, son of Capt. William T. Sampson, feeds the *New York*'s mascot goat Pitch. Young Sampson eventually became lieutenant commander and was captain of the USS *Crowninshield* destroyer in 1919. Here, he is about 11 years old. They are standing next to the field gun used for salutes. (LOC.)

The *New York*'s ship's tailors enjoy a moment of rest with their apparent mascots and tools of the trade. They had to take care of the sewing needs of 53 officers and 422 enlisted and 40 marines. (LOC.)

Aboard the USS *New York*, haircuts and improvised music from mandolins, guitars, snare drum, tuba, banjo, and tambourine were the order of the day. These men were all probably members of the ship's orchestra. Note the man in the middle rear having a shave. (LOC.)

Four

THE COMMANDERS
1899–1906

This chapter highlights the various commanders of the North Atlantic Fleet and some of the individual ships they commanded while in Rockport. All had interesting and colorful careers and commanded vessels all over the world as America's Navy grew and expanded its influence globally. Many of these men returned to Rockport several times, some commanding different vessels. All graduated from the US Naval Academy and participated in the Spanish-American War and most in the Civil War in their younger days. Many had naval vessels named after them. Interestingly, they are all buried at Arlington National Cemetery.

Rear Adm. Robley Dunglison Evans commanded the Great White Fleet on its worldwide cruise from the Atlantic Ocean through the Straits of Magellan to the Pacific Ocean.

Although he was never actively engaged in the fighting, Rear Adm. William Thomas Sampson was known for his victory in the Battle of Santiago de Cuba during the Spanish-American War.

Rear Adm. Winfield Scott Schley commanded the Flying Squadron of the Battle of Santiago de Cuba in the Spanish-American War aboard the flagship USS *Brooklyn*. He was never given credit for his heroic role in the battle.

Rear Adm. Francis John Higginson was the last commander in chief of the North Atlantic Squadron and first commander in chief of the newly created North Atlantic Fleet and commanded the blue fleet during a sham battle around Sandy Bay.

Rear Adm. John Elliott Pillsbury fought in both the Civil War and the Spanish-American War and commanded the white fleet in maneuvers on Cape Ann in 1902.

Admiral of the Navy George Dewey was the only person to have attained the rank. He is best known for his victory at the Battle of Manila Bay during the Spanish-American War, which he commanded from his flagship USS *Olympia*.

Adm. George Dewey graduated from the US Naval Academy in 1858. He went on to fight in the Civil War, serving first on the frigate USS *Wabash* and then attached to Adm. David Farragut's fleet aboard the *Mississippi* during the capture of New Orleans in 1862. After the end of the Civil War, then lieutenant commander Dewey was sent to the European station as executive officer of the USS *Kearsarge*, the famous ship that had sunk the Confederate privateer *Alabama*. (LOC.)

Rear Adm. George Dewey, commander of the US Asiatic Squadron, is seated fourth from the left with officers of his flagship, USS *Olympia*, and his staff on board in Manila Bay in May–June 1898. This photograph was taken just after his victory of the Battle of Manila on May 1, 1898, when he destroyed the Spanish Pacific Squadron of Adm. Patricio Montojo. (LOC.)

At right is Capt. Charles Vernon Gridley. On June 10, 1897, he was ordered to the Asiatic Squadron on the flagship *Olympia*. During his time on that station, he befriended Commodore Dewey (below). Gridley was severely ill and was about to be shipped home but was allowed to remain by Dewey during the Battle of Manila Bay on May 1, 1898. "At 5:40 when we were within 5,000 yards," Dewey later recalled, "I turned to Captain Gridley and said, 'You may fire when you are ready, Gridley.' " Dewey had put upon Gridley the responsibility for beginning the action, a compliment of the highest order. Dewey recommended that Gridley be advanced 10 numbers in the promotion list as a partial reward for his ability and judgment. Gridley was sent home on May 25 but died in transit. Four guns from the captured Spanish fleet arsenal at Cavite Island were emplaced at his gravesite. (Both, LOC.)

Pictured during a 1903 naval review on the *Mayflower* are, from left to right, (sitting) Secretary of the Navy William Moody; Pres. Theodore Roosevelt; and First Lady Edith Roosevelt; (standing) Sir Thomas Lipton, a famous yachtsmen; Admiral Dewey; C.O. Iselin; and Maj. Gen. Adna Chaffee. Dewey was the only person to be given the special rank of Admiral of the Navy and to be permitted to wear the special full-dress uniform he is wearing here. (LOC.)

Commodore Dewey, second from the right, is pictured on the bridge of the USS *Olympia* during the Battle of Manila Bay on May 1, 1898. Others present are, from left to right, Samuel Ferguson (apprentice signal boy), John A. McDougall (Marine orderly), and Merrick W. Creagh (chief yeoman). (NHHC.)

Inside the pilothouse, Quartermaster R.C. Mehrens is standing at the helm. He steered the *Olympia* during the Battle of Manila Bay. (NHHC.)

S.J. Skaw is posing with one of six deck-mounted one-pounder guns. He fired the first shot as ordered by Captain Gridley to begin the Battle of Manila Bay. (NHHC.)

49

USS *Olympia*, Dewey's flagship, is displaying the admiral's four-star flag on the aft topmast while at anchor in Manila. Her fancy filigree bow figurehead had yet to be installed in this photograph taken in 1898 (see below). The commodore's gig is shown to the right of the gangway ladder with its own four-star flag painted on the bow. *Olympia* is the oldest steel warship still afloat. (NHHC.)

USS *Olympia* flagship is shown in Rockport Harbor in August 1902. The stern exhibits a very ornate aft plate filigree design surrounding its name. She was nicknamed "Queen of the Pacific." The bar hanging out from a cable is the propeller guard so small craft (and sailors) do not come too close to the twin turning screws below. Above the rope ladder are the twin eight-inch turret guns. (SBHS.)

Dewey was promoted to rear admiral in 1899 and to full admiral in 1900. He received a hero's welcome home in 1899 in New York City with a two-day parade. A special military decoration, the Battle of Manila Bay Medal (commonly called the Dewey Medal), was struck in honor of his victory. It was awarded to every American officer, sailor, and marine present at the battle. (LOC.)

John E. Pillsbury (1846–1919) was a rear admiral in the US Navy. In 1905, he served as chief of staff of the North Atlantic Fleet. He was commander of the white fleet in the 1902 Rockport naval maneuvers against Adm. Francis Higginson's blue fleet. He is best known as one of the world's foremost geographers and an authority on the Gulf Stream. (LOC.)

Rear Adm. Francis Higginson was the commander of the defending force (blue fleet) on Saturday afternoon July 18, 1902, when the North Atlantic Squadron arrived in Rockport aboard his flagship USS *Kearsarge*. His blue fleet eventually won the five-day sham battle against the attacking white fleet of Captain Pillsbury. Higginson once suspended fleet maneuvers to entertain the Duchess of Marlborough (Consuelo Vanderbilt) and her guests the Astors and the Vanderbilts. (LOC.)

Rear Adm. William T. Sampson was in command of the North Atlantic Squadron and involved early in the blockade of Cuba before war was declared on April 25, 1898. Although scheduled to lead the North Atlantic Squadron into Rockport Harbor in 1899, he was granted leave of absence and replaced by Capt. H.C. Taylor, who hoisted his broad blue pennant assuming command of the fleet. Sampson later arrived in Rockport by train. (LOC.)

Admiral Sampson stands before a gun turret on his flagship USS *New York*. Sampson sent the following message after the battle: "The Fleet under my command offers the nation as a Fourth of July present, the whole of Cervera's Fleet," when it was Admiral Schley's Flying Squadron who destroyed every Spanish vessel in a running sea battle lasting five hours. Sampson's message omitted any mention of Schley's leadership in the Battle of Santiago de Cuba in Havana, leading to a controversy as to who was responsible for the victory. (LOC.)

Admiral Sampson's unidentified steward is pictured with the admiral's pet iguana aboard the *New York*. The Navy in those days seemed to be rather lax in its rules about mascots. Besides an iguana, sailors were known to have parrots, cats, dogs, goats, a Panama sugar bear, a pig, Panama squirrel creeper, and a kangaroo. (LOC.)

Obverse SAMPSON MEDAL Reverse

The Navy authorized a service medal, known as the Sampson Medal, to recognize those who served under his command during the Spanish-American War. The obverse of the medal bears Sampson's image, and thus, he was one of only four Americans in history entitled to wear an official medal with his own image on it. Others were Adm. George Dewey, Gen. John J. Pershing, and Adm. Richard E. Byrd. (LOC.)

Sampson served on the USS *Maine*'s Navy Court of Inquiry on board the US Lighthouse Service tender *Mangrove* in Havana Harbor, Cuba, in March 1898. Seated around the table are, from left to right, Capt. French E. Chadwick, Captain Sampson, Lt. Comdr. William P Potter, Ens. W.V. Powelson, and Lt. Adolph Marix, judge advocate. Powelson provided testimony of the findings of divers working aboard the wreckage of the *Maine*. (NHHC.)

The US Navy diving crew is at work on the wreck of the USS *Maine* in Havana Harbor on September 9, 1921. The view is aft looking forward. The *Maine* had been sunk by an unidentified explosion that killed 260 of the fewer than 400 crew members. Occurring at 9:40 p.m. February 15, 1898, the cause is still a mystery as to if it was a mine or a coal bunker fire. (LOC.)

Rear Adm. Winfield Scott Schley was commander of the USS *Brooklyn* that came to Rockport in 1899. His Flying Squadron, which included the battleships *Indiana*, *Texas*, *Oregon*, and *Iowa*, was responsible for defeating the Spanish fleet in Cuba. Sampson was aboard the *New York* but could not reach the battle in time, rendering him unable to fire a single shot and depriving Sampson of any participation in the battle. (LOC.)

Schley's flagship *Brooklyn* was the fastest of the fleet, having a top speed of 22 knots, or 25 miles per hour—thus the reason his fleet was called the "Flying Squadron." A *flying squadron* is defined as any naval squadron moving rapidly from place to place at a distance from the main command. Their small group of speedy vessels enabled them to get to their appointed target quicker than an entire fleet. (LOC.)

Aboard his flagship USS *Maine* and accompanied by two divisions of the fleet, Rear Adm. Robley D. Evans was commander in chief of North Atlantic Fleet when it pulled into Rockport Harbor on July 17, 1906. The 1st Division consisted of USS *Missouri*, USS *Yankton*, USS *Illinois*, USS *Kearsarge*, and several smaller vessels. The 2nd Division included the USS *Alabama*, USS *Kentucky*, USS *Iowa*, and USS *Indiana*. (NHHC.)

Evans sits on the forward turret deck of the USS *Iowa*, which he commanded in the Battle of Santiago de Cuba in July 1898. His successes aboard the USS *Iowa* secured his reputation of one of the great admirals of the US Navy. On February 11, 1901, he was made rear admiral. (LOC.)

During the Civil War, Evans exhibited great gallantry while under fire during the attacks on Fort Fisher, North Carolina, on January 15, 1865. He was wounded four times and threatened to kill any man who attempted to amputate his leg. This injury resulted in his using a cane for the rest of his life. (LOC.)

Commanding the *Yorktown* on the Pacific Squadron, Robley D. Evans won great acclaim for his firm and skillful handling of a tense situation in Chile, becoming known as "Fighting Bob" Evans. He took pride in his new nickname, and his reputation for profanity also led to his being chastised by his hometown pastor Leonard Woolsey Bacon. (LOC.)

Admiral Evans salutes Pres. Theodore Roosevelt as he leaves the bridge of the president's yacht *Mayflower* after reviewing the Great White Fleet prior to its departure on a round-the-world tour in 1907. Evans's flagship USS *Connecticut* is in the background. (LOC.)

Five

THE "BLUE AND WHITE" WAR
1902

In 1902, the North Atlantic Squadron was renamed the North Atlantic Fleet. In 1905, the European and South Atlantic Squadrons were abolished and absorbed into the North Atlantic Fleet. As the "New Navy" was growing, the need to train and recruit new sailors was critical.

On August 16, 1902, the vessels of Rear Adm. Francis J. Higginson's North Atlantic Squadron arrived at Rockport and dropped anchor not three-quarters of a mile from the shore. The squadron was divided into two divisions. The 1st Division was comprised of the flagship *Kearsarge*, battleships *Massachusetts* and *Alabama*, and dispatch boat *Scorpion*, and the 2nd Division had the cruisers *Olympia*, flagship of Admiral Dewey's Manila fleet, and *Brooklyn*, famous in the battle of Santiago, and the dispatch boat *Mayflower*, the future presidential yacht. On August 19, a fleet of seven torpedo boat destroyers arrived that morning and anchored in the harbor.

Capt. John E. Pillsbury would arrive a day later with his fleet *Panther* and *Prairie*, both auxiliary cruisers, and the *Supply*, which was appropriately named as it was a supply ship. This fleet would be the attacking white fleet.

A sham battle was conducted around Rockport and Thacher Island that extended as far as Provincetown on Cape Cod and Portland, Maine. The objective of the attacking white fleet was to seize some undefended anchorage between Portland and Cape Cod and hold a port for six hours without being opposed by a superior force. On the morning of August 24, after four grueling days at sea, the white fleet struck its colors and surrendered to Admiral Higginson's ships about eight miles south of Thacher Island.

ON WEDNESDAY.

Naval War Game Will Begin Then.

Capt Pillsbury Will Try to Land on New England Coast.

He Has the Prairie, Panther and the Supply.

Admiral Higginson's Squadron Will Try to Stop Him.

Ships Under Sealed Orders at Rockport, Mass.

Newspaper stories followed the exploits of both commanders for a week, with daily reports of sightings and much conjecture as to their strategies of battle. Admiral Higginson was commander of the defending blue fleet, and his job was to destroy and or capture the attacking white fleet of Captain Pillsbury. Pillsbury's vessels were smaller and could hide better at sea. (*Boston Globe*, August 19, 1902.)

In August 1902, *Olympia*, the flagship of Admiral Dewey; battleships *Massachusetts*, *Alabama*, and *Kearsarge*; the cruisers *Brooklyn*, *Montgomery*, and the future presidential yacht *Mayflower*; dispatch boats *Gloucester* and *Scorpion*; and auxiliary cruisers *Panther* and *Prairie*; and seven torpedo boats visited. The *Massachusetts* shows her signal flags as a sign of celebration of the fleet's arrival and a salute to the people of Rockport. (SBHS.)

A searchlight display was put on by the ships, and lights were strung to outline their vessels; "the fleet was illuminated with electric lights [that] gave the impression that a great city had suddenly appeared seaward; the moon made it possible to distinguish each ship," noted the Gloucester Times. The music on board could plainly be heard onshore (each ship had its own orchestra). (SBHS.)

On August 19, seven torpedo boats—USS Bagley, Bailey, Biddle, Stockton, Porter, Decatur, and Farragut—entered Rockport Harbor. At the Norfolk Navy Yard, around 1907, are (front right) USS Bagley and USS Bailey and (front left) USS Biddle, the two larger boats are, from left to right, USS DuPont and USS Porter. These were part of the torpedo boat flotilla that had "sunk" the blue fleet in Rockport Harbor. (LOC.)

This July 1906 photograph was captured from Pigeon Hill in Rockport looking toward Sandy Bay. One newspaper reported, "Viewed from the shore the marine picture is inspiring. The white hulls, immaculate in their brilliant hue, with their top hamper and funnels of government yellow, looked like huge birds of prey sitting upon the water, willing yet loath to show their terrible talons." Straitsmouth Island can be seen in the far right. The breakwater is between the *Iowa* and

Kearsarge in the far distance. The ships are, from left to right, *Indiana*, *Iowa*, *Kearsarge*, *Alabama* (or *Illinois*), and *Maine* (or *Missouri*). The local press estimated that 8,000 people came to town and viewed the ships. Tradesmen and provision dealers did a land office business. Every owner of a craft capable of transporting people did a big business from shore to the warships, which were open to visitors. (SBHS.)

TORPEDO BOATS WIN.

Two Attacks on Ships at Rockport.

First Destroyed the Whole Fleet.

Showed a White Light in Harbor.

Battleships Showed Red Lights.

Next Time Three Torpedo Boats Were Captured.

Four Got Away Despite Fierce Cannonading.

Crowds Gazed on the Display of Searchlights.

The torpedo boat destroyers conducted their own sham battle on the evening of August 20 when the USS *Porter* entered the harbor to the north near Halibut Point and steamed down on the fleet unobserved and showed a white light, which denoted that she got within the zone of danger to the anchored ships. The squadron acknowledged defeat by showing a red light. The *Alabama* was the first to be "torpedoed," followed by the *Massachusetts* and the *Mayflower*. This torpedo boat could have sunk the entire fleet had this been a real instead of mimic warfare. The defending fleet won the overall contest, as it could "sink" the remaining torpedo boats using its giant searchlights. (Left, *Boston Globe*, August 20, 1902; below, NHHC.)

Higginson captured the Pillsbury squadron on August 24. The signal sent was, "Surrender; demand unconditional," from Rear Admiral Higginson's flagship, and the reply was "accept surrender" from the fore-truck of the *Prairie*, Commander Pillsbury's flagship. The battle ended eight miles south of Thacher Island when the enemy failed to make the harbor at Salem surrounded by the battleships *Kearsarge*, *Alabama*, and *Massachusetts*; torpedo boat *Barney*; and the dispatch yacht *Scorpion*. (*Boston Globe*, August 21, 1902.)

TO SEIZE AND HOLD A PORT

Pillsbury's "White" Squadron The Attacking Force.

Higginson's "Blue" Ships Moved From Rockport at Noon.

From Portland to Cape Cod the Coast is Being Swept by Scouts, and Battleships and Cruisers Are Held Ready to Pounce on the Unwary Enemy—Port Must be Held for Six Hours Without Being Opposed by a Superior Force to Constitute a Victory.

USS *Alabama* is shown with its name spread across its bridge. At night, this sign was illuminated by hundreds of lightbulbs. She had a top speed of 16 knots (18 miles per hour). At 374 feet long, she was one of the *Illinois*-class pre-dreadnought battleships with a displacement of 12,250 tons. (NHHC.)

This is *Alabama*'s 13-inch gun crew posing with one of its shells. A handwritten caption (not shown) states that this was the champion gun crew and Lieutenant Clark was its leader. Tests had shown that gun crews were only 32 percent accurate when firing at targets nine miles away. (LOC.)

This 13-inch gun crewman poses inside the barrel of his gun. The T-shirt with the A (*Alabama*) and a knot indicates that he is a rookie seaman yet to earn his A-shirt without the knot. The ship was armed with a main battery of four 13-inch guns. (NHHC.)

Alabama moored in port in June 1901. This stern view shows her large national ensign, twin 13-inch guns, and outrigger propeller guards deployed. She had a crew of 536 men. *Alabama* boasted the smallest man in the Navy on board: a 12-year-old lad, Richard Wainwright Jr., the bugler. He was the son of Cmdr. Richard Wainwright, who made the name USS *Gloucester* famous in the Spanish-American War. (NHHC.)

Alabama was decommissioned and used as a target ship on September 15, 1921. Under the supervision of Gen. Billy Mitchell, she was bombed with chemical bombs, including tear gas and, as seen in this photograph, white phosphorus. Four Martin NBS-1 bombers attacked with 300-pound bombs at an altitude of 1,500 feet. A final armor-piercing 2,000-pound bomb blew a fatal hole in her hull. (NHHC.)

Battleships were given hull numbers. Hull number BB-1 was the *Indiana*, while hull number BB-2 was the *Massachusetts*, and the *Kearsarge* was hull number BB-5. The last hull number was BB-64, the *Wisconsin*, commissioned in 1944. Battleships were named after one of the 48 contiguous states, except for the *Kearsarge*, which was named for a sloop-of-war from the Civil War, named by an act of Congress. The only state not represented was Montana; construction

of the *Montana* (BB-51) was canceled because of the Washington Treaty for Limitations of Naval Armaments. Alaska and Hawaii did not become states until 1959, after the end of battleship building. Massachusetts, Indiana, Iowa, and Maine each had three battleships named for them; most other states had one or two. This is a cutaway view of the USS *Kearsarge* showing the intricacies of its layout, its two engines, boilers, ammunition and powder magazines, major turret guns, and funnel stacks. (NHHC.)

Kearsarge is at a dry dock in Bremerton, Washington, on May 30, 1908. She was armed with four 13-inch, four 8-inch, and fourteen 5-inch guns along her main deck between the turrets. Armor was 16 inches thick at the waterline, and turrets used 15-inch-thick nickel steel plating. The 1,210 tons of coal she carried acted as additional armor around engine rooms and magazines; this amount of coal allowed her to travel 6,000 miles. (NHHC.)

Kearsarge had an 8-inch turret above her 13-inch turret. Her dual searchlights on the conning tower mast could illuminate the night for up to a half mile. In April 1906, she suffered a severe explosion killing six men and wounding 14 as powder ignited in the forward turret while guns were being unloaded after practice. The accident occurred near Guantanamo, Cuba. Official correspondence indicated neglect or carelessness. (NHHC.)

Kearsarge carried a complement of 40 officers and 514 enlisted men; she was very well manned for a ship of her size. The ship's Marine Guard is on the right wearing helmets. Note the sailor with a cat mascot at lower right. (NHHC.)

Kearsarge had several sports teams, including baseball (1904–1905 champs), rowing, football, and swimming. Most competed in Rockport during their stay in 1902 and again in 1906. Competitions were held against other ships and against local teams. (NHHC.)

During her trials on Cape Ann on September 24, 1899, *Kearsarge* averaged 16.8 knots an hour and covered 66 nautical miles to Cape Porpoise, Maine. It was remarked in one newspaper story that "the bone in her teeth" was very fine to look at and kept the forward deck wet up to the 12-inch gun turret. Note that her broadside battery of five-inch guns had not yet been installed. (NHHC.)

The crew of the *Massachusetts* is enjoying a beer break under the awning on the aft turret deck. The ship's purser was the most popular guy on deck. It is not clear what the man in the derby is doing there, but maybe he is the beer distributor. (NHHC.)

Pictured is the berth deck of the *Massachusetts*. Men are writing letters, shining shoes, and trying to get some shut-eye. Cramped quarters in hammocks was the usual lot for the enlisted man. (NHHC.)

The junior officers' mess aboard the *Massachusetts* features white tablecloth, glassware and silverware, and bowls of fruit. The stewards are standing at attention in the rear left. (NHHC.)

The tailor shop on the *Massachusetts* was kept busy with a crew complement of 473 officers and men. The sign behind the men reads, "Ship's Tailors orders attended too promptly." Sailors are in their summer whites, and two men seem to have deep tans, which probably indicates they are on a Caribbean tour. (NHHC.)

USS *Olympia*, a 5,586-ton protected cruiser, was commissioned February 1895. Her initial service was as flagship on the Asiatic Station and she participated in the Battle of Manila. From 1902 to 1906, she was active in the Atlantic, Caribbean, and Mediterranean. Decommissioned in December 1922, she is now a museum ship at Philadelphia, Pennsylvania, where she remains today as the sole floating survivor of the US Navy's Spanish-American War Fleet. (NHHC.)

Pictured is the figurehead and stern ornament plate of USS Olympia while in dry dock at Boston Navy Yard on November 4, 1901. These ornaments were added during her overhaul in 1900. It was titled "Herald of the Empire." They were designed by famed sculptor Augustus Saint-Gaudens for $12,000. He designed the famous US $20 double-eagle gold piece in 1905, reputed to be one of the most beautiful coins ever minted. (NHHC.)

A very young-looking crew of the Olympia was part of a complement of 33 officers and 395 enlisted. They are standing around the ship's field gun and one of her Colt Gatling guns and in front of the twin eight-inch Mark 4 guns. These guns fired a 250-pound projectile and used a 105-pound brown powder service charge. They rotated 137 degrees and elevated to 15 degrees. (LOC.)

Here is the crew's mess aboard the *Olympia*. Note the table suspended by rope to rock with the ship to avoid a real mess. No white tablecloths here, only porcelain mugs and bowls instead of glassware. Note that each man tucks his kerchief into his breast pocket to keep it out of the food. (NHHC.)

The mazy waltz is seen performed aboard the *Olympia*. It was used many times as a social activity for Admiral Dewey and his special guests. (NHHC.)

Olympia's ship band consisted of 16 musicians, who were first- and second-class seamen, per her roster from 1898 in Manila. While in Rockport Harbor, the bands could often be heard onshore by the residents and hotel guests. (NHHC.)

USS *Scorpion*, a 775-ton yacht, was built in 1896 at South Brooklyn, New York, as the civilian yacht *Sovereign*. Purchased by the Navy in April 1898, she served off Cuba during the Spanish-American War. *Scorpion* was mainly used as a dispatch vessel for the North Atlantic Fleet and was decommissioned and sold in 1929. (NHHC.)

USS *Gloucester*, a 786-ton yacht built in 1891 at Philadelphia as J.P. Morgan's *Corsair*, was obtained by the Navy in April 1898. She served during the Battle of Santiago on July 3, 1898. She was 240 feet long with a beam of 27 feet. She was lightly armed with four 6-pounders, two of which can be seen on her foredeck. She was struck from the Navy list in 1919, and her fate is unknown. (NHHC.)

USS *Mayflower*, a 2,690-ton yacht, was built for private use at Clyde Bank, Scotland, in 1896. She was acquired by the Navy in preparation for the Spanish-American War and participated in the engagement. Following the war, *Mayflower* served as a headquarters and flagship in Atlantic and Caribbean waters. In 1904, she was converted to the presidential yacht and performed this role until being decommissioned in March 1929. (NHHC.)

Six

FUN AND GAMES, A SOCIABLE NAVY 1906

The most exciting and interesting arrival of the Navy occurred in 1906, led by Rear Adm. Robley "Fighting Bob" Evans aboard his flagship USS *Maine*. He brought two divisions of the Atlantic Fleet, which included the USS *Alabama, Kearsarge, Iowa, Missouri, Illinois, Indiana, Kentucky*, and the gunboat *Yankton*. Having once individually commanded all the battleships mentioned above plus the *Connecticut, Ohio* and the cruiser *New York* between 1895 and 1907, Admiral Evans was a very high-profile naval officer. This visit brought the most battleships ever to Sandy Bay. He arrived in June and did not leave until August. He and his crews were entertained and given the run of the town, and special arrangements were made for crew members at the town hall. The crews accounted for over 5,000 men, which equaled the population of Rockport at the time. The postmaster "Uncle" Bill Parson was quoted as saying, "On each mail the letters and packages came in voluminous quantities. This morning's mail brought over 5,000 pieces." Several family members of the crews were put up at local hotels including the Turk's Head Inn, Ocean View House, Edward Hotel, and the Hawthorne Inn Casino, as well as at private homes. Banquets, dinners, and receptions were held all over town. Baseball games at the South End, Winter's Field, and at Webster's Field were numerous and were played by town teams as well as teams from the ships. In return, the ships put on spectacular searchlight exhibitions, and each ship's band played regularly on board as well at the various hotels. About 10,000 people came for the searchlight displays. The ships set up visitations and ferry service from T-Wharf many afternoons, so hundreds of citizens could board the ships. This chapter recounts the activities, the ships, and the personalities that took over Rockport for three months that summer of 1906.

In both photographs is Capt. Robley Evans. The unsigned picture was taken when he commanded the USS *Iowa* in 1898. He led his Atlantic Fleet, which included eight ships, into Sandy Bay on July 17, 1906, aboard his flagship USS *Maine*. He was welcomed with a 21-gun salute by Rockport officials on shore. Evans returned the salute with a window-rattling 13-gun salute from his six-inch guns. (NHHC.)

This handsome August 17, 1906, view is of the stern of the USS *Maine*. The small craft at far left was the launch owned by Rockport resident Chester Gott, who mounted the canopy and took parties out on the water to visit ships of the Great White Fleet in Sandy Bay. (SBHS.)

Rear Adm. Robley "Fighting Bob" Evans, commander in chief of the Atlantic Fleet, arrived in his flagship USS *Maine* (center). Accompanying him were the battleships *Missouri, Illinois, Kearsarge, Indiana, Kentucky,* and *Alabama* and the cruiser *Yankton.* Some 5,000 men were aboard these vessels, duplicating the population of the town. (SBHS.)

USS *Maine* was the largest of her class—at 394 feet long, 72 feet wide, with a displacement of 13,500 tons—and had replaced the one blown up in Havana Harbor in 1898. She is distinguished from other vessels as the only battleship with three smokestacks. (*Gloucester Daily Time,* August 22, 1902.)

THE MAINE ARRIVES.

Largest Ship of Her Class Will Be Tried Off Here To-morrow.

The United States Battleship "Maine" arrived at Boston yesterday, and is now in readiness for her trial trip off here over the Cape Ann-Cape Porpoise course to-morrow.

THE NEW BATTLESHIP MAINE.

USS *Maine* is shown here in Rockport Harbor just after its sea trials on August 23, 1902. Newspaper reports about the *Maine* were datelined, "Turk's Head Inn, Rockport. Her trial began as most others did at Thacher Island and ran up to Cape Porpoise, Maine. The course was 72 knots divided into 10 sections attaining an average speed of 18.8 knots per hour. She sports four 12-inch rifles, sixteen 6-inch rapid fire, eight 14-pounders, eight 3-pounders." The area around Cape Ann and the harbor of refuge became a popular site for sea trials for many newly built battleships and cruisers. The list includes the following: USS *Massachusetts*, April 26, 1896; USS *Brooklyn*, August 25, 1896; USS *Iowa*, April 8, 1897; USS *Kearsarge*, September 24, 1899; USS *Kentucky*, November 25, 1899; and USS *Alabama*, August 23, 1900. (NHHC.)

Here, the new USS Maine crew is photographed on February 10, 1903, after her commissioning on December 29, 1902. Men are gathered around the twin 12-inch, .40-caliber gun turret on the foredeck. Note the capstan on the left, the anchor chains, and the small pram and boarding floats stored on the right. Maine had a complement of 561 officers and enlisted. (NHHC.)

Pictured is Maine's torpedo room with an 18-inch torpedo hanging above on the monorail track, ready to be dropped down into the torpedo firing tube. The track below will guide the tube to be fired in any direction along an arc of 15 degrees. Maine had two of these tubes submerged in her hull on the broadside. (NHHC.)

USS *Maine* broadside battery of 6-inch, .50-caliber Mark 6 guns is trained out, as crewmen watch around 1904. Note the steam cutter in foreground. For close-range defense against torpedo boats, she carried six 3-inch, .50-caliber guns mounted in casements alongside of the hull, eight three-pounder guns, and six one-pounder guns. (NHHC.)

The USS *Maine* is pictured here in Rockport's Sandy Bay in 1906. This was taken by local photographer and owner of Rockport Photo Bureau, Charles Cleaves. This is from one of thousands of glass-plate negatives now owned by the Sandy Bay Historical Society and was made into one of Cleaves's best-selling postcards. (SBHS.)

By July 20, 1906, Evans's fleet included 16 battleships; two divisions of cruisers; three divisions of gunboats; the 2nd Division flotilla of destroyers, which included *Macdonough*, *Truxton*, *Worden*, *Stuart*, *Lawrence* and *Hopkins*; and a fleet of small government tenders. A total of 35 vessels were anchored in Sandy Bay. This fleet was one of the most formidable naval forces ever assembled under the American flag, according to the *Boston Daily Globe*. (SBHS.)

USS *Macdonough* torpedo destroyer was joined by five others for maneuvers, which took place offshore during the fleet's stay. Awaiting instructions as to where their exercises would be performed, she sits just south of Andrews Point in Rockport. (SBHS.)

Flying the builder's flag of William Cramp and Sons, USS *Iowa* is churning up the water as she completes her sea trials at Cape Ann. Edwin Cramp himself was aboard for the trial and was pleased at her performance doing an average 17 knots over the 66-mile course, exceeding her contract speed by one knot and winning a bonus of $25,000 for her builders. (NHHC.)

THE LATEST ADDITION TO UNCLE SAM'S NAVY.
The Battle-ship Iowa at the Conclusion of Her Trial Trip, Just After Passing Cape Ann.

This newspaper illustration accompanied an article about *Iowa*'s sea trials. The *Iowa* is depicted passing the Twin Lighthouses of Thacher Island on her way to Cape Porpoise in Maine. She covered the course for an elapsed time of 3:52:47. USS *Iowa* arrived with the 2nd Division of the fleet, including the *Kentucky*, *Alabama*, *Indiana*, and *Illinois*, under the command of Rear Admiral Davis on July 19, 1906. (*San Francisco Call*, April 8, 1897.)

These are shrapnel holes *Iowa* suffered from the Spanish fleet during the 20-minute battle with the cruisers *Infanta Maria Teresa* and *Almirante Oquendo*. *Iowa*'s effective fire set both ships aflame and drove them onto the beach. Commanded by Captain Evans, *Iowa* was the first to spot the Spanish fleet trying to escape Santiago Harbor and then fired the first shot of the war. (NHHC.)

Nothing seems to change in the Navy, KP (kitchen police) duty is an ongoing chore. Potatoes still must be peeled. These eight men need to peel enough potatoes to feed the USS *Iowa*'s complement of 683 men. (NHHC.)

The *Iowa* was used as a target ship and was sunk in the Gulf of Mexico by the USS *Mississippi* on March 21, 1923. She was hit by thirty 14-inch shells during fleet gunnery practice. Note her forward smokestack has collapsed. (NHHC.)

On July 20, 1906, one of the social events of the season took place at the Turk's Head Inn, where a magnificent banquet was arranged by the local establishment for Rear Admiral Evans and 50 of the line officers and guests Sen. Henry Cabot Lodge, Atty. Gen. William H. Moody, and many others. The *Maine*'s Band gave a concert during the banquet and provided music for dancing. (SBHS.)

The Ocean View Hotel in Pigeon Cove was the location where Admiral Evans's wife, Charlotte Taylor Evans, resided during the admiral's fleet visit in July and August. His ship *Maine* was anchored closest to shore and could be seen from the upper porch of the hotel. Evans spent many nights with his wife during her stay. For entertainment, Evans often brought the *Maine*'s Marine band to play for the hotel guests on the veranda. (SBHS.)

Sailors were welcomed by the townspeople who turned the town hall into a dormitory and meeting place for the sailors. Fifty cots were set up in the auditorium, and writing desks, souvenir letterhead and pens, ice cream, coffee and donuts, and reading material were provide. The lawns were decked with electric lights, so the men could gather at night. (SBHS.)

Sailors crowd onto the electric trolley car on their way to Gloucester for shore leave and baseball. Note the baseball players in their uniforms. The young man chasing the car wears the uniform of the gunboat USS *Yankton*, another in his summer whites holds out a baseball toward the photographer. *Yankton* lost to the *Kearsarge* 2-0. More than 1,550 sailors took liberty that day. (SBHS.)

Here, sailors walk the streets of Rockport in Dock Square at the entrance to T-Wharf in the center. One of the fleet's battleships is streaming smoke in the left distance. Motif No. 1 is seen to the left of the warship. Police reported no problems or incidents during the "Jackies" stay in town. (SBHS.)

Sailors are towed by the *Kearsarge* steam cutter in two longboats to T-Wharf in Rockport, where they were to enjoy a few days off before returning for maneuvers at sea. Each ship had its own fleet of longboats, steam gigs, cutters, or captain's barges to shuttle crews and officers to and from the vessel. (SBHS.)

Admiral Evans was a noted baseball fan and encouraged team play among the crews. Ensign Leahey of the *Maine* was baseball director of the fleet and conducted the final games of the 1906 championship in Rockport. The real fight for the championship was between the nines of the *Iowa* and the *Kentucky*. The photograph shows the *Iowa* team as fleet champs in 1907. (NHHC.)

The *Kearsarge*, *Missouri*, *Alabama*, and *Kentucky* had their names outlined in lights across their bridges. Thousands of people came each evening to watch the searchlight spectacle. (NHHC.)

This man aboard the *Iowa* aims the machine gun, and behind him is one of the many searchlights used to signal other ships. Radio had not yet been adopted by the Navy, and communication was by signal lights or flags. Dispatch vessels were used for critical messages to flagships. Lights like this one were used to put on searchlight shows for the public to enjoy. (LOC.)

Thousands came to visit the ships each day. Ships were usually open to the public in the afternoons and the ship's launches picked up visitors at T-Wharf to ferry them to the ships. Many private boats got into the action as well and did very well for themselves financially for the two months the fleet was in town. (SBHS.)

Here is the ship's band from the USS *Mayflower* in 1898 while in the Caribbean near Puerto Rico. It was reported in the local newspaper in 1915 that the Norwegian steamer *Bergenhaus* was saved from wrecking on the rocks of the Dry Salvages in heavy fog near Thacher Island upon hearing the band music from one of the warships anchored in Sandy Bay. (NHHC.)

This photograph was taken looking down from the foremast top onto the foredeck of the *Missouri*. Note the 12-inch shells spread out on the deck being prepared for target practice around 1918. The battleship's forward 12-inch, .40-caliber gun turret is also seen. On April 14, 1904, an accident in her after 12-inch gun turret took the lives of 36 of her crew. (NHHC.)

Pictured in 1909, *Missouri* only had one cage mast, but by 1911, she had two. She is also painted in "haze gray," which the entire Navy switched to around 1910. The years of the Great White Fleet were over, and the great gray fleet took precedence. *Missouri* was used to ferry American soldiers back from Europe after World War I, when she carried 3,278 soldiers back to the United States on four trips. (NHHC.)

USS *Illinois* in 1905 is distinguished by her side-by-side stacks like her sister ship *Alabama*. She served with the North Atlantic Fleet until 1907. She had a series of mishaps, colliding with two other battleships, the *Missouri* in March 1903 and the *Alabama* in July 1906 near Sandy Bay. (NHHC.)

The *Illinois* gun crew is at the six-pounder firing from a raised platform. There are three guns shown here, part of a complement of 16 on the ship. See the oars and longboats stored above their heads. This area of the ship was called the casement. (NHHC.)

Here, torpedo practice is taking place on the *Illinois* with the 18-inch Whitehead torpedo. *Illinois* had four 18-inch deck-mounted torpedo tubes. Over time, torpedoes on battleships were abandoned because they were inaccurate and of limited use because of their very limited range. (NHHC.)

USS *Kentucky* is pictured during her sea trials near Cape Ann in November 1899. Note her 14 broadside five-inch guns have yet to be installed. In her 20 years of service, she never participated in major combat. Commissioned in 1900, she was a *Kearsarge*-class battleship designed to be used for coastal defense. Her two three-cylinder vertical triple-expansion steam engines and two propeller shafts generated 12,179 horsepower. (NHHC.)

Kentucky, like USS *Kearsarge*, had two double turrets, with two 13-inch, .35-caliber guns and two 8-inch, .40-caliber guns, each stacked on two levels. *Kentucky* had a low freeboard, often making her guns unusable during bad weather as water flooded her decks. She was armed with 54 guns and 4 torpedo tubes. (LOC.)

The *Kentucky* crew is loading 13-inch armor-piercing shells for target practice. Note the rope-webbing rig and the block and tackle used to haul the shells up from the magazine deck below. Each shell weighed 1,130 pounds. The guns had a firing range of 10,000 to 12,000 yards depending on the elevation angle. The time of flight varied from 18.9 seconds to 22.5 seconds. (LOC.)

The *Kentucky*'s captain's cabin is quite ornate and nicely appointed with Persian rugs, leather chairs and couch, a bar, flowers, and separate sleeping quarters. Capt. Colby Chester is seen sitting at his desk around 1901. (LOC.)

USS *Yankton* gunship is anchored here in Hampton Roads on December 10, 1916. Originally built as private yacht *Penelope*, she was a steel-hulled schooner built in 1893 at Leith, Scotland. She was acquired by the Navy in May 1898 and renamed *Yankton*. She was purchased to augment the fleet bound for Cuba prior to the Spanish-American War. (NHHC.)

Seven

THE GREAT WHITE FLEET IN ROCKPORT
1902–1915

Although the Great White Fleet never came to Rockport en masse, the battleships came individually before and after their famous 14-month around-the-world tour from December 1907 to February 1909. Eight of the 16 ships arrived multiple times between 1902 and 1915.

Because of the fleet's record during the Spanish-American War and world cruise, the ships' visits were received with great excitement and fanfare by the populace on Cape Ann.

When the fleet left for its 43,000-mile cruise, the descriptions in the nation's newspapers were glowing and poetic. *Harper's Weekly* noted the following:

> The fleet which passed out from Hampton Roads is the most powerful massing of sea-fighters under a single command which has been accomplished in the New World . . . when the signal of the Commander-in-Chief was flashed from the flagship, sixteen great craft, with their fourteen thousand souls aboard, hove anchor and swung to place in line with the ease and precision of a drill squad. It was wonderful to watch that line steam past, to note the power of each ship as she glided by.

The president's yacht, *Mayflower*, approached the fleet as 21-gun salutes were fired from each ship as she passed by in review. Rows of men in blue were massed along the main decks of the white fighting ships in a ceremony called "manning the sides." Each sailor's arms were spread to their fullest length, hands resting on the shoulders of his next neighbors. At eight bells, a signal was wigwagged from the *Connecticut*, Rear Admiral Evans's flagship. Instantly, every ship broke out from stem to stern, from masthead to masthead, the most gorgeous array of signal-flags, red, yellow, blue, white, black, and green. The bands on all the ships beat out "The Star-Spangled Banner." The column of 16 ships, placed at 400-yard intervals in four divisions on their way to San Francisco, was three miles long.

This chapter is dedicated to the Great White Fleet and its commanders both in Rockport and as they prepared for their world tour.

The 1st Division of the Great White Fleet, commanded by Rear Adm. Charles S. Sperry, includes, clockwise from top left, USS *Connecticut*, USS *Kansas*, USS *Vermont*, and USS *Minnesota*. (NHHC.)

The 2nd Division of the Great White Fleet, commanded by Rear Adm. Richard Wainwright, includes, clockwise from top left, USS *Georgia*, USS *Nebraska*, USS *Rhode Island*, and USS *New Jersey*. (NHHC.)

The 3rd Division of the Great White Fleet, commanded by Rear Adm. William H. Emory, includes, clockwise from top left, USS *Louisiana*, USS *Virginia*, USS *Ohio*, and USS *Missouri*. (NHHC.)

The 4th Division of the Great White Fleet, commanded by Rear Adm. Seaton Schroeder, includes, clockwise from top left, USS *Wisconsin*, USS *Illinois*, USS *Kentucky*, and USS *Kearsarge*. Note *Wisconsin* and *Nebraska* replaced *Maine* and *Alabama* before leaving San Francisco. (NHHC.)

Commanding officers of most of the fleet's ships are pictured in 1908. Those present include, from left to right, (sitting) Capt. Hugo Osterhaus, of *Connecticut*; Capt. Kossuth Niles, of *Louisiana*; Capt. William P. Potter, of *Vermont*; Capt. John Hubbard, of *Minnesota*; Capt. Joseph B. Murdock, of *Rhode Island*; and Capt. Charles E. Vreeland, of *Kansas*; (standing) Capt. Hamilton Hutchins, of *Kearsarge*; Capt. Frank E. Beatty, of *Wisconsin*; Capt. Reginald F. Nicholson, of *Nebraska*; Capt. Thomas B. Howard, of *Ohio*; Capt. William H.H. Southerland, of *New Jersey*; Capt. Walter C. Cowles, of *Kentucky*; Capt. John M. Bowyer, of *Illinois*; Capt. Alexander Sharp, of *Virginia*; and Lt. Comdr. Charles B. McVay, of *Yankton*. Not present were Capt. Edward F. Qualtrough, of *Georgia*, and Capt. Robert M. Doyle, of *Missouri*, and also the four division commanders, Rear Adms. Charles S. Sperry, Richard Wainwright, William H. Emory, and Seaton Schroeder. (NHHC.)

This photograph was taken from the Congregational church steeple in downtown Rockport in 1906. This is the "old harbor" with a sailboat entering through the harbor breakwater. Great White Fleet vessels shown are, from left to right, *Kentucky*, *Kearsarge*, *Iowa*, *Maine* (or *Missouri*), *Indiana*, *Alabama* (or *Illinois*), and *Missouri* (or *Maine*). The small ship is an unidentified torpedo destroyer. (LOC.)

The idea of sending the new battle fleet around the world was the brainchild of the energetic "Teddy" Roosevelt, former colonel of the Rough Riders and onetime assistant secretary of the Navy. Assuming the presidency after the assassination of Pres. William McKinley in 1901, Roosevelt brought to the White House a deep conviction that only through a strong Navy could a nation project its power and prestige abroad. (LOC.)

Roosevelt stressed the upgrading and expansion of the US fleet to protect American interests abroad. From 1904 to 1907, American shipyards turned out 11 new battleships to give the Navy awesome battle capabilities. This was timely, for in 1906 hostilities with Japan seemed possible; the Japanese navy dominated the Pacific and posed a potential threat to the Philippines. (LOC.)

The presidential yacht (center) is saluted by the Great White Fleet prior to the fleet embarking on its around-the-world tour from Hampton Roads, Virginia, on December 16, 1907. Hundreds of excursion boats and bunting-bedecked pleasure craft swarmed about the floating battlewagons. Cliffs and beaches were black with spectators. (NHHC.)

Aboard the USS *Mayflower*, Pres. Theodore Roosevelt reviewed the fleet at Hampton Roads before its 43,000-mile world tour. Each ship in the fleet gave the president a 21-gun salute as the *Mayflower* traveled between the ranks of ships. This photograph captures the scene with the smoke from the guns around her. (NHHC.)

Rear Adm. Robley Evans meets with President Roosevelt aboard the *Mayflower* just prior to leading the fleet to San Francisco on the first leg of the world tour. The president was reported to have said the following to Admiral Evans: "One word before you go, your cruise is a peaceful one, but if it turns out otherwise you realize your responsibility." (NHHC.)

From left to right, Admiral Davis, First Lady Edith Roosevelt, Admiral Evans, President Roosevelt, and Commodore Cornelius Vanderbilt are aboard the *Mayflower* prior to the fleet's departure. The ostensible purpose of the trip to San Francisco was to allay the fear of Californians that their coast was threatened by Japanese invasion and to convince Japan that it no longer dominated the Pacific. (NHHC.)

The president tips his hat as the battleships pass in review. Note the crewmen standing at attention on deck of the passing *Illinois*. A total of 29 ships passed by for review. When Roosevelt was standing on the *Mayflower*'s bridge, he had one hand guarding his high silk hat against the wind. "By George!" he was heard to exclaim above the furor, "Did you ever see such a day and such a fleet!" (NHHC.)

The USS *Connecticut* at right leads the fleet out of Hampton Roads to begin its world tour. She is followed by USS *Kansas*, in center, and the USS *Vermont* astern of *Kansas*. The first leg would take them to Brazil, around the Straits of Magellan to Chile, Peru, Mexico, and on to San Francisco, traveling 14,556 miles. (NHHC.)

The USS *Maine* leads the 3rd Division on the first leg from Hampton Roads, next astern is USS *Missouri*, followed by USS *Minnesota* and USS *Ohio*. Cargo aboard was geared to the sailors' recreation—24 grand pianos, 60 phonographs, 300 sets of chess, equipment for handball, quoits, and billiards. For self-indulgence, 200,000 cigars and 400,000 cigarettes. Almost a million pounds of flour, a million pounds of fresh beef, and 40,000 dozen eggs. (NHHC.)

The USS *Kansas* tests her 7-, 8-, and 12-inch guns off the Virginia coast at the start of the trip. The fleet carried 35 million tons of ammunition in the magazines and a thousand guns to hurl it at a target; it was five times more powerful than any fleet America had yet assembled. (NHHC.)

Here, men aboard the *Ohio* polish the barrels of the 6-inch, .50-caliber broadside guns during the Great White Fleet's world tour. Battleships of the time carried between sixteen and twenty 6-to 8-inch guns. These smaller guns, designed for a day of wooden frigates when battles had been decided at close quarters, were virtually obsolete. The Navy had intended to replace them but never did. (NHHC.)

Arriving in Australia, Lt. John E. Lewis, US Navy, was presented with a mascot kangaroo on board the USS *Connecticut*. It was presented to the ship by the citizens of Sydney when the fleet visited in late August 1908. (NHHC.)

The prizewinning gun crew of the USS *Georgia* is posing on their 8-inch and 12-inch guns on the 1908 world cruise. The *Georgia* was the flagship of the 2nd Division, which included the *Nebraska*, *New Jersey*, and *Rhode Island*, under the command of Rear Adm. Richard Wainwright. (NHHC.)

Dusty sailors pose for a photograph after coaling ship aboard the USS *Mississippi*. Ships would normally go into port and take on coal every two weeks. "Coaling ship" was an all-hands evolution and a dirty job. It would take several days to coal a ship. Afterward, the crew would spend several more days cleaning the ship, inside and out, forward and aft, since coal dust settled everywhere. (NHHC.)

A member of the "black gang" on the battleship *Connecticut* described coaling day as follows: "Our ship held about 2,000 tons of the stuff. All deckhands would go down into the collier (coal supply ship) and fill these big bags with about 500 pounds. Then they'd hoist 'em over to us down in the coal bunkers and we'd spread out the coal with shovels until all the bunkers—about 20—were full to the top." (NHHC.)

The president was very excited to visit each of the flagships *Connecticut*, *Georgia*, *Louisiana*, and *Wisconsin* to speak to the crews. He climbed on the barbette of the aft turret with its 12-inch rifles to address the crew of the *Connecticut*. He told them he was satisfied with the work in gunnery thus far accomplished. "You have done A1 in smooth water" said the president, "but what I want to see next year is a target practice in rough water." The men burst into cheers, and he continued, "For if you ever have to fight you can't choose your water." (NHHC.)

The fleet arrived home on February 22, 1909. Twenty battleships and five cruisers, forming a six-mile-long line, came in through the rain-shrouded sea and passed in review of the president aboard his flagship *Mayflower*. They steamed to their anchorages and, forming a double line three miles long, swung to their chains in the tide. Fifteen of these ships had girdled the globe, traveling 43,000 miles. (NHHC.)

Here is the president with sailors after their world tour. The president declared that this was the first "battle fleet ever to circumnavigate the globe" and that any other nation that attempted a similar performance must follow in the footsteps of America. He later said, "Nobody will ever forget that the American coast is on the Pacific as well as on the Atlantic." (SBHS.)

A crowd of local tugs and excursion steamers welcomes the fleet home at the end of the cruise. Note the officer in special full-dress uniform on the embarkation ladder, at right, as the captain's steam gig approaches. Besides the throngs afloat, there were more than 50,000 people who had secured some point along the shoreline and beaches of Cape Henry, Virginia. (NHHC.)

Newspaper cartoons celebrated the fleet's return. This one by artist William Allen Rogers shows Uncle Sam, George Washington, and Theodore Roosevelt welcoming the fleet. Washington's hatband reads "February 22nd," the arrival date. The fleet's return date was also the date of Washington's birthday celebration. (LOC.)

The voyage had set many records, like unparalleled endurance (434 days), touched the equator five times, and visited more continents (6) and more countries (26) than any other navy on a single cruise. The fleet consumed more coal (435,000 tons at a cost of $1,967,553), wore out more shovels (an average of 250 on each ship), and burned 100,000 rounds of saluting powder. (NHHC.)

Here, the USS *Michigan* takes on coal from the collier USS *Jason* while off Vera Cruz, Mexico, in April 1914. Note the ship's band atop Turret No. 2 playing to encourage the crewmen at work moving coal. The USS *Michigan* burned 8–12 tons per hour at full power. (NHHC.)

Eight

THE END OF THE BREAKWATER AND THE BATTLESHIP
1915

By 1916, the Age of Sail was passing to the Age of Steel and Steam as wooden sailing craft were no longer the order of the day for the Navy.

In 1915, a letter to the secretary of war was sent from the Corps of Engineers, "recommending that legislation be enacted authorizing the abandonment of the project for the construction of the Harbor of Refuge at Sandy Bay, Cape Ann, Mass." Congress stopped all future appropriations that year.

The granite business on Cape Ann was fading as more municipalities began using asphalt and cement for roads, and the need for paving stones disappeared, eventually forcing the Rockport Granite Company to close in 1930.

Naval visits to Rockport began to be severely curtailed because of the war. The year 1915 saw only six battleships in Rockport, and from that year until 1950, visits were sporadic, with only one or two ships appearing.

Even battleships were becoming obsolete. Most of the 31 ships built from 1895 to 1910 had been scrapped by 1919. The development of torpedo destroyers, and later aircraft and guided-missile cruisers, replaced the need for these gigantic battlewagons. Today, no battleships remain in service or in reserve with any navy worldwide. The only battleships and cruisers left in the United States today are on display as museums, including *Alabama*, *Arizona*, *Iowa*, *Massachusetts*, *Missouri*, *New Jersey*, *North Carolina*, *Olympia*, *Utah*, and *Wisconsin*.

The era from 1910 to 1920 was the beginning of many societal, technological, and economic changes. Immigration hit an all-time high of 8.8 million in 1910; the Sixteenth Amendment brought the federal income tax; Ford introduced the assembly line in 1913; the Panama Canal opened in 1914, making it easier for the US Navy to get to the Pacific; World War I broke out in 1914; the Eighteenth Amendment brought on Prohibition in 1919; the Nineteenth Amendment allowed women to vote. The first woman in the Navy was enlisted in 1917.

This chapter looks at how these changes affected the harbor of refuge project.

64TH CONGRESS, } HOUSE OF REPRESENTATIVES. { DOCUMENT
1st Session. } { No. 411.

HARBOR OF REFUGE AT SANDY BAY, CAPE ANN, MASS.

LETTER

FROM

THE SECRETARY OF WAR,

TRANSMITTING,

WITH A LETTER FROM THE CHIEF OF ENGINEERS, REPORT ON REEXAMINATION OF HARBOR OF REFUGE AT SANDY BAY, CAPE ANN, MASS.

DECEMBER 16, 1915.—Referred to the Committee on Rivers and Harbors and ordered to be printed, with illustrations.

WAR DEPARTMENT,
Washington, December 15, 1915.

The SPEAKER OF THE HOUSE OF REPRESENTATIVES.

SIR: I have the honor to transmit herewith a letter from the Chief of Engineers, United States Army, dated July 23, 1915, together with copies of reports from Col. W. E. Craighill and the Board of Engineers for Rivers and Harbors, dated June 21, 1915, and June 30, 1915, with maps, on reexamination of harbor of refuge at Sandy Bay, Cape Ann, Mass., made in compliance with the provisions of the river and harbor act approved March 4, 1915.

Very respectfully,

LINDLEY M. GARRISON,
Secretary of War.

WAR DEPARTMENT,
OFFICE OF THE CHIEF OF ENGINEERS,
Washington, July 23, 1915.

From: The Chief of Engineers, United States Army.
To: The Secretary of War.
Subject: Reexamination of harbor of refuge at Sandy Bay, Cape Ann, Mass.

1. Under authority of section 14 of the river and harbor act approved March 4, 1915, there are submitted herewith for transmission

On December 15, 1915, the secretary of war transmitted to Congress the latest recommendation of the US Army chief of engineers. The report states that total expenditures had amounted to $2 million and an additional $5 million would be needed to carry it to completion. It also cites that its benefits had been superseded by the advent of "staunch steamers" with reduced transit times between ports and "better advice regarding weather." The conclusion is that "these things tend to lessen the value and importance of a harbor of refuge as originally contemplated." Therefore, "abandonment" of the project is recommended. Federal funding ceased completely in 1916. (SBHS.)

On August 23, 1915, when the last 50,000-pound header stone was lowered in place, only 922 feet of the planned 9,000-foot superstructure had been completed. The final L-shaped structure measured 201 feet on the western arm and 721 feet on the southern arm. A total of 2,086,480 tons of stone had been used. (SBHS.)

Here is the final completed 922 feet of superstructure of the breakwater at the "dogleg" point, which extended in two directions—toward Andrews Point in the northwest and toward Avery's Ledge to the south. It was originally planned to extend 3,600 feet south from Abner's Ledge to Avery's Ledge, then 5,400 feet northwesterly from Abner's Ledge toward Andrews Point. Only about two-thirds of the substructure grout work was completed. (SBHS.)

In 1915, federal inspectors recommended the breakwater not be completed, stating in their report that "the net result of the reexamination was that the benefits to be derived from completing this harbor of refuge were not sufficient since coastal steamers were replacing schooners in these waters." The project was officially abandoned by 1917, although several attempts to restart it occurred right up to 1972. (SBHS.)

The Rockport granite industry took a major hit in the 1920s and 1930s when paving stones (its biggest-selling product) were being replaced by asphalt and cement highways and roads. In 1912, the local granite industry was dealt another blow. The contract for supplying stone went to an outsider, and granite was imported from Hurricane Island, Maine. By June 1930, the Rockport Granite Company was out of business. (CAM.)

From 1899 until 1910, Sandy Bay would see anywhere from 10 to 35 Navy ships, battleships, cruisers, torpedo destroyers, dispatch boats, submarines, and auxiliary supply craft in the harbor. In 1911, eight battleships arrived, and by 1920, only sporadic visits of one or two vessels; many years, none appeared. Only three ships—USS *North Dakota*, destroyer USS *Bancroft*, and USS *Delaware* (pictured here)—appeared in 1919 just outside Rockport Harbor. (SBHS.)

Thousands of people gathered on the shore to view the ships in the harbor. Shown here are the *Delaware*, *Nebraska*, and *Michigan*. By 1911, most ships had been painted gray, and cage masts were installed, giving the ships a very different look from the earlier "buff-and-white" paint schemes. (SBHS.)

In 1915, Adm. DeWitt Coffman, fleet commander, concerned that private boaters were charging too much, volunteered his barges to take people to the ships for free. The local boatmen reduced their fees from 50¢ to 30¢ per round-trip. Here, at T-Wharf, two of the fleet's steam barges are tied up to the dock to load passengers while a private boat passes by with paying customers. (SBHS.)

In 1911, the USS *Delaware* visited Rockport and invited residents to visit. *Delaware* was accompanied by the USS *Nebraska*, *Michigan*, *Ohio*, *Kansas*, *New Hampshire*, *South Carolina*, and *Vermont* from August 5 to 18. The *Delaware* had recently returned from England, where she headed the procession of ships at the coronation of King George V. She was a massive, dreadnaught-class ship, displacing 20,000 tons and measuring 510 feet long with a crew 1,326. (SBHS.)

Soon after the Great White Fleet returned from its world tour, it was recommended by Rear Admiral Sperry to abandon the white-hulled, spar-colored upper decks. He stated, "It was not appropriate to have 'Holiday Colors' going into battle." The USS *Michigan* is fully dressed in flags, with her crew manning the rails during the naval review off New York City on October 3, 1911. She displays her new haze-gray paint job. (NHHC.)

All battleships were outfitted with cage, or basket, masts from 1910 to 1920. They were an improvement over the tripod masts, saving weight and allowing lookouts to see the fall of their shots, and were less vulnerable to enemy fire while providing a location for fire control equipment. They were designed to take multiple direct hits from enemy fire without collapsing. This is the USS *Illinois* after conversion in 1923. (NHHC.)

Twelve obsolete battleships, including most of the Great White and North Atlantic Fleets, were either broken up and sold for junk, used for target practice, or put into reserve shipyards. These battleships are lined up at the Philadelphia Navy Yard in the Reserve Basin on October 22, 1919, ready for the scrap heap. From left to right are *Iowa, Massachusetts, Indiana, Kearsarge, Kentucky,* and *Maine.* (NHHC.)

In 1922, the Washington Naval Treaty was signed by the major powers who had won World War I—the United States, Britain, Japan, France, and Italy—and agreed to prevent an arms race by limiting naval construction of battleships, battlecruisers, and aircraft carriers. It also meant that many US ships were to be scrapped. Pictured in 1923, guns are being removed from the USS *Kansas*, and in the background, the USS *South Carolina* is dismantled. (NHHC.)

Visitors clamor down the gangway of the pier at T-Wharf in Rockport Harbor to get on the steam cutters going out to the USS *Michigan* in 1911. Note the M on the bow designating the *Michigan*. Women's frilly hats, long skirts, and umbrellas were the fashion. Annual visits by the Navy were severely reduced after the Sandy Bay Harbor of Refuge project was abandoned. In 1919, only two battleships visited. (SBHS.)

Times were changing in a positive way. On March 17, 1917, Loretta Perfectus Walsh became the first woman to enlist in the US Navy—and the first woman allowed to serve in any of the US armed forces as anything other than a nurse. Today, there are over 52,000 women in the Navy. This recruiting poster, designed by the famed artist Howard Chandler Christy, seems a bit sexist today. (LOC.)

125

In 2007, the Navy renewed its annual visits to Rockport with a new squadron of vessels. It was composed of the US Naval Academy Offshore Sail Training Squadron aboard four Naval Academy 44-foot sailboats. Although not warships, these sleek sailing vessels provide oceangoing training opportunities for the young midshipmen just as the original battleship fleets did over 100 years ago. The 60 crew and advisors spend the middle weekend each July in Rockport and are housed by citizens of Rockport. This reignited an annual tradition of "Navy Weekend" organized and managed by the Rockport Navy Committee, whose goal is to encourage the entire community to interact with and learn about the US Navy. Many of the same events are held as they were in 1900, such as baseball games with residents, pancake breakfasts, kickball games with the kids, community projects, tours of the surrounding communities, and public tours of the sailboats. Echoes of the ships' bands were revived with annual visits by the Navy Band Northeast's Pops Ensemble, which comes each year to play for the citizens of Cape Ann at the local high school. The four sailing vessels arriving in 2014 were named *Audacious*, *Intrepid*, *Fearless*, and *Valiant*. (Courtesy of Skip Montello.)

Bibliography

Babson, Herman. "The Building of the Breakwater." *New England*, October 1894.
Cameron, Douglas B. *A National Harbor of Refuge: The Sandy Bay Breakwater Project.*
Carter, Samuel, III. *The Incredible Great White Fleet.* New York: Macmillan Publishing, 1971.
Department of the Army New England Division, Corps of Engineers. *Review of Federal Navigation Project Harbor of Refuge Sandy Bay, Cape Ann, Massachusetts.* 1972.
Dewey, George. *Autobiography of George Dewey, Admiral of the Navy.* New York: Charles Scribner's Sons, 1913.
Office of the Chief of Naval Operations. *Dictionary of American Naval Fighting Ships.* Washington, DC: Naval History Division, 1963.
Reckner, James R. *Teddy Roosevelt's Great White Fleet.* Annapolis, MD: Bluejacket Books, Naval Institute Press, 1988.
Sandy Bay Harbor of Refuge Committee. *Harbor of Refuge at Sandy Bay, Cape Ann, Mass.* 1886.
Trask, David. *The War with Spain in 1898.* New York: Macmillan Publishing, 1981.
www.history.navy.mil.
www.loc.gov/pictures.
www.navsource.org.

DISCOVER THOUSANDS OF LOCAL HISTORY BOOKS FEATURING MILLIONS OF VINTAGE IMAGES

Arcadia Publishing, the leading local history publisher in the United States, is committed to making history accessible and meaningful through publishing books that celebrate and preserve the heritage of America's people and places.

Find more books like this at
www.arcadiapublishing.com

Search for your hometown history, your old stomping grounds, and even your favorite sports team.

Consistent with our mission to preserve history on a local level, this book was printed in South Carolina on American-made paper and manufactured entirely in the United States. Products carrying the accredited Forest Stewardship Council (FSC) label are printed on 100 percent FSC-certified paper.

MADE IN THE USA